D0524466

£4

The Art of Remembering

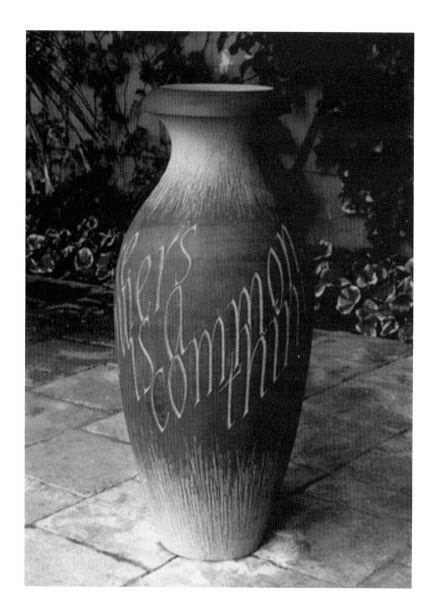

The Art
of
Remembering

EDITED BY

Harriet Frazer and
Christine Oestreicher

Memorials by Artists

CARCANET

This book accompanies the exhibition *The Art of Remembering*, curated by Harriet Frazer and Christine Oestreicher.

First published in Great Britain for *Memorials by Artists*, Snape Priory, Saxmundham, Suffolk IP17 1SA, by Carcanet Press in 1998.

Introduction copyright 1998 © Lucinda Lambton
Text copyright 1998 © individual authors
Photographs copyright 1998 © Oliver Riviere
Photographs in 'Traces of Immortality'
copyright 1998 © David Robinson

All rights reserved. No part of this publication may be reproduced or transmitted in any form or by any means, electronic or mechanical, including photocopying, recording or any information storage system, without permission in writing from the publishers:
Carcanet Press
Conavon Court
12-16 Blackfriars Street
Manchester M3 5BQ

British Library Cataloguing in Publication Data
A catalogue record for this book is available from the British Library

ISBN 1-85754-377-7

Book designed by Stephen Raw

Printed and bound by SRP Ltd, Exeter.

Illustration of exhibit opposite title page by David Crowe

CONTENTS

SOPHIE

BEHRENS

writer

18 985

Foreword

HARRIET FRAZER

It is an extraordinary chance that *The Art of Remembering* exhibition should coincide with the tenth anniversary of the founding of *Memorials by Artists*.

My great hope is that the exhibition, and this book, will spread the word widely—the word that people can have beautiful individually made memorials, that design and fine lettering are important, and that the whole process of creating a memorial with the lettercutter/carver/mason can be a deeply rewarding thing to do.

I had the idea for *Memorials by Artists* following the experiences our family had over the commissioning of the headstone to my step-daughter Sophie, who died in 1985.

Throughout the twelve months it took for Sophie's stone to be made I kept thinking about the problems our family had encountered and how difficult it had been to find someone who could design and carve a beautiful memorial. I knew it could not be possible that we were the only family who didn't want to order a headstone from a catalogue. We found too that if the wording or carving was to be at all 'unusual', it could be difficult gaining permission for the memorial from the church authorities.

Memorials by Artists' aim is to ease people's way through this often unknown territory (how do we choose the stone, what words shall we have, what will the church or cemetery authorities allow and so on). We try to help people to have the memorials that they want, or suggest alternatives to their ideas, if for one reason or another they prove unsuitable. We also try to help anyone who wants advice and information on this whole subject.

The Art of Remembering is dedicated to the memory of Sophie. It is due to the person she was in her life, and what happened following her death, that the idea for *Memorials by Artists* came about, and so this exhibition. Her headstone stands in Salle churchyard in Norfolk—about four miles, as the crow flies, from Blickling.

Art should speak to us across centuries

INTRODUCTION

BY

LUCINDA LAMBTON

'Art should speak to us across centuries; it is the means by which we break bread with the dead'. This quotation, carved into a boulder, encapsulates the very essence and excellence of this exhibition, *The Art of Remembering*—an inspiring array of modern memorials which will be on display at Blickling Hall, Norfolk for eight exhilarating and exemplary months.

To see these extraordinary works is to rejoice that, at long last, a grave wrong is being put right. For with their dignity and artistic dash they will surely triumphantly trounce the bureaucracy that has laid cultural and artistic waste to almost all our churchyards and cemeteries.

Up until the beginning of the twentieth century, burial grounds were created as morally uplifting oases—Elysian fields of monumental sculpture and design reflecting the dreams and ideals of the age. Not so in the last half of the 20th century when 'God's Acre' has often been reduced to a sterile strip, swept clear of all spirit. The unholy demand for 'maintenance free' plots, as well as rules and regulations as to size and what can be said and carved on memorials, have combined to impose the grimmest uniformity of blightingly blank blocks marching roughshod over our remains.

To be surrounded by most modern memorials, is to be surrounded by the sorriest developments of the fifties, sixties and seventies and these contemporary monstrosities are still being built, hand over fist, with the same blinkered fervour of the post-war years. Great tracts of consecrated land have been, and still are, falling victim to grim modernistic worlds in miniature. A mere glance at some of the diocesan rules will show you just how grim. No stone should be higher than 4 feet nor lower than 2 feet, they decree, or narrower than 1 foot 8 inches, and no memorial more than 6 inches thick, nor less than 3. There are other equally detailed restrictions about statues and images, such as 'The headstone is to have no decorative motif other than vertical lines or a small cross or small flower, if so desired'. As if that were not enough (which it is) to choke all spirit out of the churchyard, there are stringent strictures about wording such as the chilling dictum from one diocese that inscriptions 'be neither presumptuous nor laudatory'.

What woeful waste of lost opportunities! Memorials were, and should still be, works of art that chronicle the community, celebrating its diversity with hearty huzzahs for the individual, while at the same time stirringly memorialising them for each succeeding generation. How keenly you sense the lives, for example, of railwaymen William Pickering and Richard Edger, who were both killed in an accident in Ely on Christmas Eve, 1845.

The Line to heaven by Christ was made
With heavenly truth the Rails are laid
From Earth to Heaven the line extends
To Life Eternal where it ends.
Repentance is the Station then
Where Passengers are taken in.
No Fee for them is there to pay
For Jesus is himself the way.
God's word is the first Engineer
It points the way to Heaven so clear,
Through tunnels dark and dreary here
It does the way to glory steer.

God's love the Fire, his Truth the Steam,
Which drives the Engine and the Train,
All you who would to Glory ride,
Must come to Christ, in him abide
In First and Second and Third Class,
Repentance, Faith and Holiness,
You must the way to Glory gain
Or you with Christ will not remain.
Come then poor sinners, now's the time
At any Station on the Line,
If you'll repent and turn from sin
The Train will stop and take you in.

Within the space of this one beautifully lettered headstone, the men and their professions as well as the period in which they lived, are recorded for all eternity with both elegance and humour.

How ignorant by contrast will be the stranger who alights on the final resting places of late 20th century man. So often buried beneath a soulless slab, in an 'easy to maintain', shorn-of-all-spirituality churchyard, his character and achievements are unknown to all passers-by.

Even a 19th century trout—at Blockley in Gloucestershire—had an inscription that summed up his life: 'Under the soil an old fish do lie, 20 years he lived and then did die. He was so tame you understand, and he would come and eat right out of your hand.' With 'The Memory of an Old fish' inscribed at the top of the tomb and with his portrait beneath the verse, this mere trout's life must have touched the thousands who have seen it since 1855. It is tragic to realise that we have had so little hope of such appreciation of contemporary man.

Through *The Art of Remembering* we are enabled to see that there is a possibility of effecting a wondrous change to these bleak horizons. After so many barren years, with Eric Gill and his disciples flying lone flags of excellence, here on display is an assembly of lettercutters and carvers in stone and wood, who are primed to restore dignity and inventiveness to commemorative art.

On the crest of this splendid wave, there is a Statue of Liberty-like figure, who, with beacon aloft, has been shining freedom into the churchyard for the last ten years: Harriet Frazer, who, with her organisation 'Memorials by Artists' has established a nationwide service to put the bereaved in touch with the craftsman or woman most suitable to their needs. Thanks to her advice and to her subsequent slogging through diocesan boards and local councils in pursuit of planning permission on our behalf, there are hundreds of modern memorials beautifying Britain today.

The range of expertise in this exhibition is enormous, with works in stone and slate, as well as cast iron and wood, all wrought into a multitude of forms: We see headstones galore, as well as a square 'poem column' of Portland stone. Then there is a slate cat, as well as a carved and lettered archway of York stone. A bell, cupped hands, urns, vases, plaques, bowls and boulders, etc., etc., etc. Hallelujah!

Now, with superb support from the Crafts Council and Eastern Arts as well as The National Trust, *The Art of Remembering* has burst upon a public bludgeoned blind by bureaucracy over the last half century.

Once again we will be able joyfully to 'break bread with the dead'. ◆

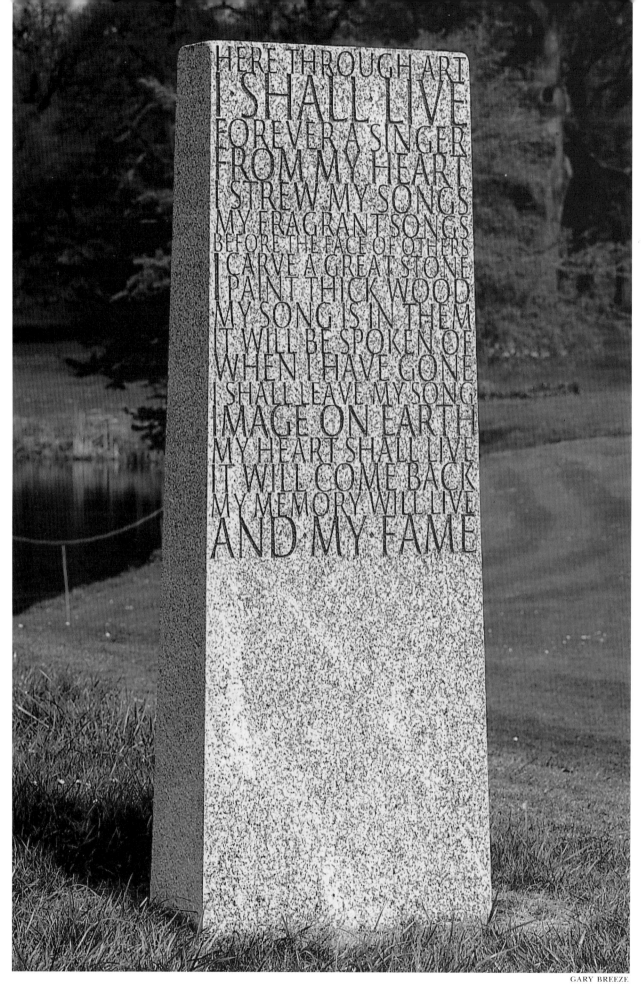

GARY BREEZE

Living Memorials

ALAN POWERS

At first sight, the idea of putting up headstones or other kinds of memorials may seem un-problematic. It is something that has been done in England for a long time, a cultural tradition with simple and straightforward rules. Parish churches and their churchyards are the familiar context. Over time they have become reposito-ries of local memory, museums of arts and crafts and records of changing social patterns. They represent stability and continuity at the centre of a community.

The tradition of churchyard memorials goes back to the seventeenth century but examples before 1700 are rare. The lettering on the earliest outdoor gravestones tends to be un-skilled. During the Georgian period monuments became one of many commodities available to a wider public in what has been called 'the consumer revolution'. They were examples of skilled artisan work, with certain distinctive local variants on national fashions. The rococo style of the mid eighteenth century, with its free-flowing lettering and shell-based cartouches was particularly suitable for the stonemason's art. The top of the stone is cut with the curves and counter curves which have remained the normal pattern. The upper part of the stone, above the lettering, is decorated with Father Time or sometimes angels' heads, which, one guesses, may sometimes be based on the face of the person buried. After rococo came a more severe style, with classical urns and more restrained lettering, based on printers' type.

John Betjeman described a typical country churchyard in the introduction to Collins Guide to English Parish Churches, in 1958, 'Wool merchants and big farmers—all those not enti-tled to an armorial monument on the walls inside the church—generally occupy the grand-est graves. Their obelisks, urns and table tombs are surrounded with Georgian ironwork. Parish clerks, smaller farmers and tradesmen lie below plainer stones. All their families are recorded in deep-cut lettering. Here is a flourish of 18th century calligraphy; there is reproduced the typeface of Baskerville. It is extraordinary how the tradition of fine lettering continued, especially when it is in a stone easily carved or engraved. whether limestone, ironstone or slate.'

Churchyard monuments are further enhanced by the process of time. Lichen grows on the stone, adding to the range of colour and flaking with a rococo panache. The carving may become less crisp with time and weather, but a low evening light will bring up unexpected beauties of texture. Certain churchyards have a special quality of place, almost independent of their associated church. Perhaps it is fanciful to imagine the souls of the dead contributing to it. The living have certainly played their part through three centuries to create a balance of care and benign neglect that relieves any sense of oppression. There may be the finest trees in the village, a view of the sea or of some adjacent fine house, or a white-painted iron gate in the corner shaded by chestnut trees overhanging a brick wall, leading to somewhere out of sight. Birds will live there, wildflowers flourish in the long grass, and sometimes sheep will be found acting as natural mowers. In a churchyard, as much as in an old remote country church, things stay much the same as they have always been.

Cemeteries are separate from churches, and although small village cemeteries can share the quality of churchyards, the order of scale enlarges to cover very large sites. The movement for separate cemeteries was a response to the growth of urban population in the nineteenth century, before cremation became customary in the inter-war period. The great Victorian ceme-teries can be fascinating and beautiful places too, although their long years of neglect have left many of them in a sad state of overgrowth and vandalism, to be rescued by volunteers.

The physical existence of churches and church-yards is not to be doubted, although keeping them up is hard work. Meanwhile, the accepted idea of what they stand for has become much more fluid. The Church of England remains the established Church, but it is a century since attendance at church was deemed an in-escapable social duty. The Squire may or may

not be a village figure, even the Parson is probably part of a team ministry with several other men and women sharing parishes, no longer having the one-to-one association with a community which, history tells us, was as often claustrophobic and sour as it was benevolent. Churchgoing has not died out completely but in terms of numbers it survives rather than flourishes. Burial itself is a minority choice compared with cremation, and many burials are made in municipal cemeteries. The churchyards of country churches still receive new burials, however, and there is still plenty of business for monumental masons making gravestones.

Churchyards offer an instructive lesson in progress and civilisation. The most beautiful memorials are probably the oldest. From the 1830s onwards they take on an increasingly mechanical character, even though they may include vigorous and highly decorated letter-forms. There is less symbolic decoration and the wording of the inscriptions becomes increasingly impersonal as the Victorian age goes on. This was the great age of funerals and mourning, with a plethora of artefacts—clothing, jewellery, stationery, keepsakes—to remind the living of the presence of the dead. Perhaps death was too much on the minds of these generations which were conquering the physical world but still ignorant of the most common causes of mortality. They believed in value for money and permanence, so that instead of using the wide variety of English stones, they preferred harder stones like granite and marble which could by then be cheaply imported. These could take a glossy polish and could be regularly scrubbed, unlike the softer English stones that weather gradually. The masons' trade became increasingly organised, less of a personal and local service and the one-man stonecutter was hard put to import foreign stone and chisel away at unforgiving granite. By the early twentieth century, the standard headstone became an object devoid of aesthetic interest. The lettering was often inlaid with factory-made metal letters. The grave would reflect the self-importance of the family concerned, with a granite kerbstone and chippings to keep nature at a distance.

At this point of decline, some time before the end of the nineteenth century, a small number of art-conscious people tried to do something better. No biography of a famous man would be complete without a picture of his grave, so there was some incentive to create something outside the ordinary. Interesting and unusual ideas were found, like the cartoonist and novelist George du Maurier's simple medieval wooden structure in Hampstead churchyard, or the architect Philip Webb's designs for stone memorials, like the one for William Morris at Kelmscot, Oxfordshire, designed as a cross inscribed on a coffin-shaped piece of stone, cambered to the sides like the roof slopes of a little sheltering building.

William Morris is a key figure in charting the reversal of the decline in memorials, even though he had no personal part in making any. It was his inspiration to others to resist the trend towards ugliness in furniture, textiles, tableware and other ordinary articles that created the Arts and Crafts movement, a body of designers and workmen dedicated to making things as fine in their way as the products of the past. This, they contended, almost necessarily involved hand work rather than machine work. It required a sensitivity to nature's materials and nature's patterns. Often, their products looked like those made before the Industrial Revolution, but they were not copies. Rather, they were seeking inspiration from the same sources and relatively unconcerned with novelty for its own sake.

The design of special one-off memorials was initially the province of the architects of the Arts and Crafts movement, including figures such as Henry Wilson and Edwin Lutyens. Although Morris was a fine calligrapher and occupied himself with the design of typefaces for printing, it was only after his death that a revival began in carved lettering. The Arts and Crafts movement, surprisingly, had little feeling for good lettering, tending to use debased and exaggerated letterforms drawn with a thin pen. Even though their styles have had a revival of popularity, the lettering on architectural drawings by C. F. A. Voysey and Charles Rennie Mackintosh is evidence of this. What was needed was a return to first principles of letterforms, combined with a revival in authentic materials and techniques. This was pioneered by Edward Johnston, a sensitive and scholarly man and an inspirational teacher, who quickly created around him a young band of enthusiasts. Most famous of them was Eric Gill, who discovered the world of lettering at evening classes while he was apprenticed to an architect at the beginning of the century. He wrote in his *Autobiography* of his first

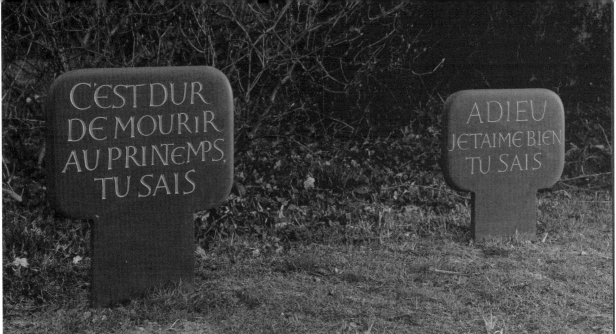

BETTINA FURNÉE

encounter with Johnston, 'It was as though a secret of heaven was being revealed.' Gill is the only name involved with lettercutting that the average art-lover will recognise. It was by becoming designer and maker in one person that Gill effected a revolution, tentative at first, but opening the way for others to follow without necessarily imitating his personal manner.

At this time, the more exceptional, one-off memorial was often a wall ('mural') plaque or monument inside the church, and Gill made a number of these, too, before returning to the eighteenth-century tradition of headstones in 1903. He chose English stones which cut relatively easily and made the letterforms and their spacing the essential part of the design. His letterforms were based on classical Roman letters, although he rendered them with a certain freedom and flourish, particularly the tails of his capital Rs. The spacing became a major concern and Gill, unlike the majority of letterers, did not space his inscriptions out in advance to achieve absolute symmetry, preferring to work from left to right and allow each line to develop its own intrinsic rhythm—a more conscious return to the informal practice of untrained letterers of the early eighteenth century.

Although other lettering artists soon joined Gill in this work, he remains the origin of the contemporary revival in memorial design. He typifies the designer-craftsman who takes particular cognizance of the materials and techniques involved. Even though most of his later inscriptional work was cut by members of his workshop like Joseph Cribb, he never just drew out lettering for use by an unknown workman, as an architect must usually do. The sense of imme-diacy, of design created at the point where the chisel meets the stone, is essential to the Gill tradition, and this feeling was passed on to Gill's pupils who included some of the best lettercutters of the post-war period: John Skelton, David Kindersley, Reynolds Stone and Ralph Beyer, and their pupils in turn.

Why should Gill have described lettering as 'the secret of heaven'? He might have applied this description to certain other crafts, but lettering is as good an example as any of what is traditionally seen as the divine calling of the craftsman. What Edward Johnston taught was that lettering is a precision activity but not a science. It is not an area in which self-conscious originality has much value. It depends on the finest of hair's breadth adjustments. The letterer, with a pen or a chisel, has only one chance to get these right, and must therefore enter a state of concentration while working which is akin to a state of contemplation. There is a life's discipline involved in learning not just a skill, but a way of living appropriate to the production of the work. Entering this state and enabling the work to flow is like prayer. Not for nothing did old craftsmen believe that to work is to pray: 'laborare est orare'. With the popularity of 'sacred minimalism' in music, in the compositions of John Taverner, Arvo Paart and Heinrich Gorezci, a larger number of people are now aware that the romantic strivings of the individual psyche, including the demand for innovative

modern techniques, are unnecessary in the production of a religious work of art, and are probably also contrary to its effectiveness as a means of meditation. The product is something standing apart from the worker and the process with its own objectivity. As Gill wrote, 'Letters are things, not pictures of things.' In our crowded world of things, made everywhere by unseen hands, we are unaccustomed to sensing fully the nature of things in this way, but the contemplative consciousness which the maker brought to the lettering is available to anyone approaching the work in a receptive spirit, which, luckily in this case, is just the spirit in which one is likely to stand out of doors in the presence of a gravestone, whether as family, friend or stranger.

This would be equally true of a memorial carved in the eighteenth century, whether in a polite or folk-art idiom, but we cannot recover their simpler world in which it was almost impossible to produce anything ugly. The present penalty, paid even by those with a sure instinct for beauty, is a degree of self-consciousness and the absence of an agreed and shared tradition. The contemporary stonecutter can reproduce all the characteristics of an eighteenth-century memorial, but the present-day context gives it a different meaning. Since the revival of lettering at the beginning of the century, the best new work has always needed to be exceptional, never standard. It requires an exceptional person to commission it and an exceptional person to execute it. These are the conditions under which we still live.

We should therefore expect to find a significant difference between the products of a firm of monumental masons—even those doing their best with machinery and design books—and the craftsman, whose virtue is not just to hold a chisel in his hand, but to hold an idea in his head which his hands bring to realisation on the stone (or whatever material is involved). As Gill and his friend, the poet-artist David Jones explained, this is the same kind of mindfulness in action that one expects of a trained priest celebrating the Mass, although the letterer is not required to subscribe to any specific creed. A piece of lettering is quite self-sufficient if it consists of nothing but the twenty six characters of the alphabet, as is the Mass which follows only the appointed text. Both are supreme examples of the question of 'how?' rather than the question of 'what?'

The organisation *Memorials by Artists*, in providing a focus for the commissioning of individually thought-out things, has a provocative title. In the modern western world we tend to make distinctions between artists, whose work we rate for its originality and personal expressiveness, and craftsmen, who are considered to represent a lesser level of activity. A difference certainly exists, but it does not mean that one is always better than the other. In fact the craftsman's attitude can produce work of greater strength and endurance. The notion of 'sacred art' shared among the world's great religions demands the subservience of the individual personality of the artist to the work, which has an objective character reinforced by the existence of a tradition of practice and symbolism. The misunderstanding of the difference between artist and craftsman is so ingrained that it is unlikely to be straightened out for some time to come, and we may therefore, for present purposes, consider the terms interchangeable. It is certainly not the case that the 'artist' aspect of *Memorials by Artists* is definable as pictorial work in addition to lettering.

If this account of the special nature of the letterer's craft (and, by extension, all forms of craft and art) holds good, then it should be clear why the placing of publicly-visible memorials in churchyards, or anywhere else, makes it desirable to employ the best quality of work available. Those who choose to have a burial are already in a minority and have probably chosen the place for a special reason. They will want to do the right thing by the memory of the dead person and for the sake of the cumulative quality and tradition of the burial place. The difficulty is that the ability to make confident distinctions between different levels of quality in lettering is not widespread. A few people are lucky enough to have met someone at some time in their life who has helped them to see what to other people may seem a mysterious and perhaps unreal distinction. The ability to see these differences is not a special product of social class or education, any more than is the ability to swim or ride a bicycle; in fact, like these two physical accomplishments, it is more a question of unlearning defensive reactions and letting natural bodily instincts have free play than of learning a difficult skill. The supposedly 'unvisual' nature of the English is an injustice, for our lettering tradition in the twentieth century has been broader and deeper than that

of any other country. We suffered more than most European countries from the puritan iconoclasm at the time of the Reformation, however, which deprived our churches of their sensual glories. The emphasis subsequently placed on the spoken and written word has been our compensation, and this has included the visual and poetic quality of the inscribed word.

If the twentieth century has been rich in lettering craftsmanship in Britain, then the crescendo has come at the end of the century. In the decades after the second world war, it might have been predicted otherwise, but the small band of practitioners attracted new recruits in the 'craft boom' of the 1970s and 80s, with exciting results. There are more good professional letterers at work in Britain now than ever before, which means that it is inexcusable for

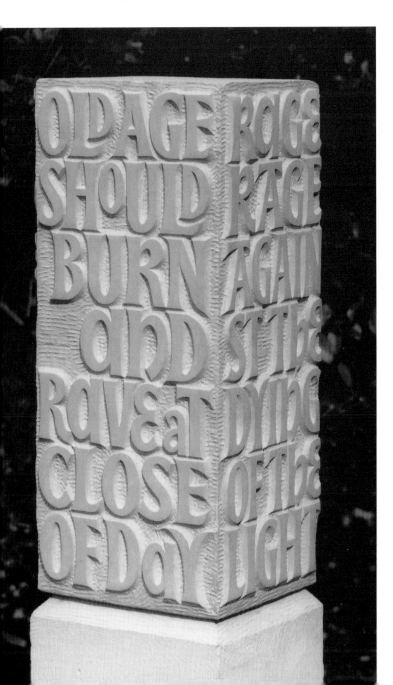

any public organisation to make do with a standard product. The feeble plaque for the opening of the Tate Gallery at St Ives (1992) is an example of an art organisation apparently blind to the value of craftsmanship.

If the Tate Gallery can get it wrong, who is to blame a bereaved person without special knowledge? But what, then, is wrong with the monumental mason's normal work? One could tick off a number of factors which are not directly related to the examples of quality which are being held up for exhibition here. The type of stone, for example, might not be the main issue, although it is in the nature of the trade to offer hard and shiny stones which suit their mode of production. Style of lettering is another obvious area of aesthetics, but since stone-cutting machines now work by computer, anything that can be done on paper can be done on stone—even a deep V cut, the form of incision which normally reads best out of doors.

What matters more than hand or machine, as Nicholas Sloan writes, is the quality of the mind that is guiding each. Pictorial devices? No problem with the almost photographic reproduction done onto polished granite by sandblasting—again, courtesy of the computer, but with the same world of difference in the quality of the design. The spacing of letters is less likely to be done well by anything but an expert eye, and here the hand of the lettercutter working direct onto stone allows for infinitesimal but crucial degrees of adjustment. The real value that an artist-craftsman brings to such a job is a sense of the totality of the work—the harmonious combination of all the elements that distinguishes a work of art. This runs from the choice of words to the choice of letterform, to the arrangement of letters, the nature of any pictorial device and the quality of finish on the faces of the stone. The whole is greater than the sum of the parts.

In terms of the distinctions between 'art' and 'trade' we inherit a situation not much different to that at the beginning of the century. It is a microcosm of the Arts and Crafts movement's quarrel with the modern world and, since it has been going on without much change for so long, it must be either a demonstration of the futility of resistance, or of its continuing importance. Assuming the possibility of a longer game, this microcosm can reveal what wider issues are at stake.

The 'art'/'trade' division involves social and economic factors as well as artistic ones. Each may be known by its fruits and judged accordingly. It is possible to move in the course of a career from one position to the other, although to do so would require a conscious mental re-orientation. The character of the 'trade' is determined by quantifiable constraints—returns on investment, profit margins, market share and goodwill in a specific geographical area. The way the product is designed, to judge from appearances, streamlines and reduces the range of variation in the components so that individuality is suppressed rather than diffused through the whole object. When individuality is introduced, it is at odds with the mechanical basis of the object and tends to become sentimentality.

There is a vast market in different forms of emotional expression. This can range from cellophane-wrapped bouquets of flowers to greetings cards. If these material tokens were not important, they would not provide such good business. Spending more money on flowers and cards does not, however, normally help to acquire an object which is better made or in better taste—if anything the reverse—but that is the nature of the system in which these trades flourish. Some commentators would be hostile to introducing the concept of taste into the discussion at all, seeing it only as a set of standards artificially constructed by a dominant class to exclude others. This is a relativist view, which assumes that all objects are equal. It is indeed necessary to prevent 'good taste' from becoming an unthinking formula, and to prevent its use as an instrument of oppression, but to prefer the monumental mason's average product to the individual craftsman's on the grounds of 'authenticity' is no more than inverted snobbery.

The difference between these two kinds of memorial is a question of value. The artist-craftsman is not a pure idealist, but a business-man or woman with a different order of priorities, putting the qualitative before the quantitative. The price for the job will be carefully considered in terms of the time and effort involved, and the skill as designer is probably not costed in at all. This person is, incidentally, a model for a future micro-economy, already partly in being, in which, as William Morris envisaged, the satisfaction of doing work is a large part of the reward. The extra money it costs to go for the best design and workmanship goes to a worthy cause. This worker's overheads are likely to be low, and he or she will probably be undercharging, in terms of the value of the work, so the extra expenditure has an immediate dividend in added value. There are few better ways of commemorating the dead than by contributing to the life of a craft.

Morris would have argued that the economic system underlying any kind of business almost inevitably affects the quality of the product. Substantial change to this system, such as Morris envisaged in his vision of the future, *News from Nowhere*, published in 1892, seems unlikely, but memorial-making is a relatively innocent aspect of the more widespread commodification of death. The *New Natural Death Handbook*, updated in 1997, is a response to the commercialisation and over-professionalisation of the business, which results in high charges for services which may not be wanted. A personal and private area of life has become the basis for an industry. It is similar in approach to the 'Campaign for Real Ale', a convincing plea for a consumer-led movement for quality and choice, which can involve the rediscovery of tradition and also a degree of innovation. *Memorials by Artists* rightly gets a mention in it. After the nineteenth century's over-concern with the trappings of death, and the twentieth century's difficulty in confronting the subject, the book opens up an unexpected prospect of healing and redemptive practices through which grief can be objectified and made beautiful. Making and placing memorials is certainly one of these, and is therefore not just a quaint continuation or revival, but part of a new and important movement. This could include poetry and theatre. The experimental theatre group Welfare State International, based in Ulverston in Cumbria, includes the devising of new rites of passage for naming babies and for funerals among its activities. There could be poets-in-residence in crematoria. These would all be ways of alleviating the burden of mourning by bringing in beauty and humanity.

The *New Natural Death Handbook* looks at the process of funerals from the environmental perspective. The inappropriate use of resources, particularly the timber used for coffins which are cremated, is one aspect. The environmental issue is also an aesthetic one, since the creation and conservation of man-made beauty goes hand in glove with respect for all living things.

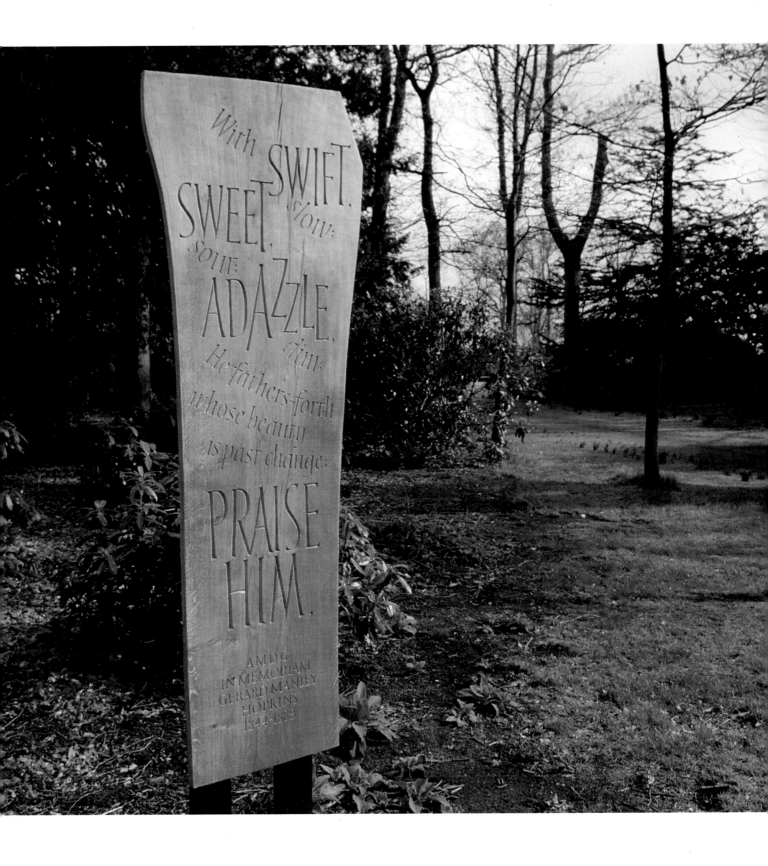

The fact that burial takes place out of doors (we would not, I suspect, wish to adopt the continental custom of ossuaries) and the options for mausoleums and vaults are strictly limited, means that there is an assumed connection between burial and the outdoors. This offers enormous opportunities not only for the preservation of rare species but for the art of the landscape designer.

Although in England we accept the idea of an old churchyard being a place of natural beauty, there still seems to be a lingering puritanism that resists beauty in newer and more urban situations. A cemetery can seldom be chosen as a burial place because it is beautiful, but this possibility is an important part of reconciling ourselves with the mystery and inevitability of death. Also, the more beautiful the place, the more people will want to visit it and the better looked-after it will be. The Scandinavian countries, more than any others, have worked positively to create the link between nature and the life cycle (which includes death) and offer examples which could still be followed. The Woodland Cemetery, Stockholm, laid out during the first World War, is one of only three World Heritage monuments dating from the twentieth century, because of its landscapes of meadow and pine wood, into which are inserted evocative chapels by the architects Sigurd Lewerentz and E. Gunnar Asplund, designs from which all inessentials have been pared away. Individual memorials in this setting are as disciplined as war graves. Children go here to play and pick wild flowers in the long grass. In Finland, everyone goes to the cemetery on All Souls Night and Christmas Eve to light candles and spend time with the dead—a folk custom relating to ancestor worship and dating from

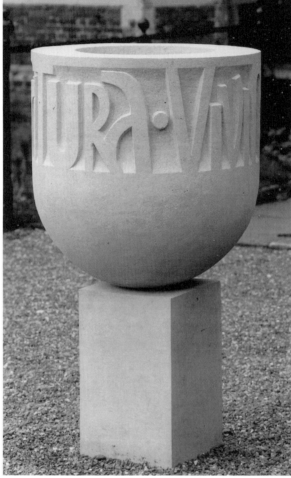

BELINDA EADE

pre-Christian times, which revived in popularity after Finland lost so many people in the war. Contrast this with the purely secular activities our children are encouraged to enjoy at Halloween.

The human response to the memorial is the justification for expending extra effort on making it. To intend an act of piety to the dead is praiseworthy, but it is the living, now and to come, who will benefit from it. To make a memorial that has human warmth is ultimately the only criterion of judgement, irrespective of correctness according to any particular canon of taste. Yet in this subjective area of emotion lie many pitfalls. The boring standard trade memorial is not just the inevitable product of a socioeconomic system, but also carefully adjusted to pacify the anxieties of those authorities who exercise jurisdiction over places of burial. Memorials up to the eighteenth century (and here we can include the sculptural tombs and monumental brasses inside the churches, going back to the thirteenth century) seemed to hold a balance between the public and private faces. In fact, anthropologists have shown how the person commemorated was conceived of in three ways: as a physical body, a social body and a monumental body. This is well described in Nigel Llewellyn's book, *The Art of Death*, which accompanied a V&A exhibition in 1991. When the physical body died, there were continuing aspects of the social body. This became the focus for mourning, and was finally replaced by the monumental body, pictured on the tomb in idealised form. Through this filtering process, any sentimentality attaching to the person was sublimated and made presentable in a public

context, so that although the monuments of this period are often very personal in their representation of the deceased, or in ascribing virtue to their lives, they also aspire to be universal. A person would very often arrange for the installation of his memorial inside a church during his lifetime. The amount of energy and money that was put into the business of dying was a kind of investment in the continuation of society.

In the regulations applied to the design of memorials in churchyards, we have inherited the tail end of this tradition of propriety, but it has become almost entirely negative and restrictive—damagingly so in some areas. A visit to a municipal cemetery shows how commercialised sentiment can place an emphasis on the individual, often with the incorporation of a photograph, yet fail to convey a sense of that individual's quality in the way that a specially-conceived memorial usually does, even if it apears less directly personal. Anglican 'good taste', which is often an excuse for avoiding the effort of thought and feeling, shies away from all overt emotion, probably with good reason, yet without knowing properly what those reasons are. The result is an arbitrary and inflexible code. One visible development during the ten-year period of the existence of *Memorials by Artists* has been an increase in the use of pictorial emblems, and a looser, more improvisatory approach to the composition of epitaphs. These may be slightly unconventional but, rather than threatening the good order of the graveyard, they may be the beginning of the discovery of a new paradigm for memorial art, to replace the long-departed one described above.

It is interesting to compare the evolution of wedding cakes during the last ten or fifteen years, as described by the social anthropologist Simon Charsley in his book *Wedding Cakes and Cultural History*, 1992. These differ in being temporary artefacts, but they share with memorials the process of objectifying one of life's rites of passage in physical and symbolic form. As with memorials, the rules are set by customs of which nobody really knows the origins, while the practice continues with a sort of momentum of its own. Also, as with memorials, there are a variety of professional services on offer which make life easier at a time of stress, but also limit the scope for creativity. The finely-finished trade article derives its status from not looking home-made. Charsley notes that after a long reign by

the impersonal, white, tiered, wedding cake as the normal form, the 1980s saw an increase in coloured icing, often including little modelled scenes relating to the interests of the couple, and the inclusion of texts. This was partly a technological change, made possible by the 'sugarcraft' movement which has become a home industry. It was also partly a reaction against the symbolic assumptions made in a 'white wedding' which are certainly not appropriate for second marriages, and a kind of revival of the representation of the 'social body'.

The making of anything for a special occasion, such as a birthday or wedding cake, has a meaning we accept without thinking too much about it. David Jones wrote about cakes as a way of explaining the inherently sacramental nature of the arts, that in the making and decorating of a birthday cake and the celebration of the Mass, 'you would witness corporeal creatures doing certain manual things with material elements and proclaiming that these things were done for a signification of something.' Memorials made impersonally cannot be works of art, and the operative effect of the knowledge that the memorial is made for someone, the living as well as the dead, is perhaps the fundamental distinction which separates the art from the trade. What remains difficult is to find the right form of expression for this personal quality. Theologically and aesthetically, the answer may come from the word 'Grace'. As the ex-Dominican Matthew Fox writes, 'Grace is the bias of the Spirit in favour of beauty, blessing and goodness. Grace is divine life coursing through history and creation and us.' This, rather than a rule book of patterns and maximum sizes, must be the criterion for adjudicating the suitability of memorials, where at present the rules are often unnecessarily restrictive.

So far, I have discussed the 'art' content of memorials chiefly in terms of lettering. This will always be present, but where a pictorial motif is introduced, the nature of the work alters and a correspondence is set up between the two elements. The picture may be something as predictable as heraldry, but in recent years it has become common to include a representation of the interests of the person commemorated. For the designer, this can be an unwelcome task as the interests may be too many or too banal to create a good-looking composition. Yet the pictorial element makes the memorial into what

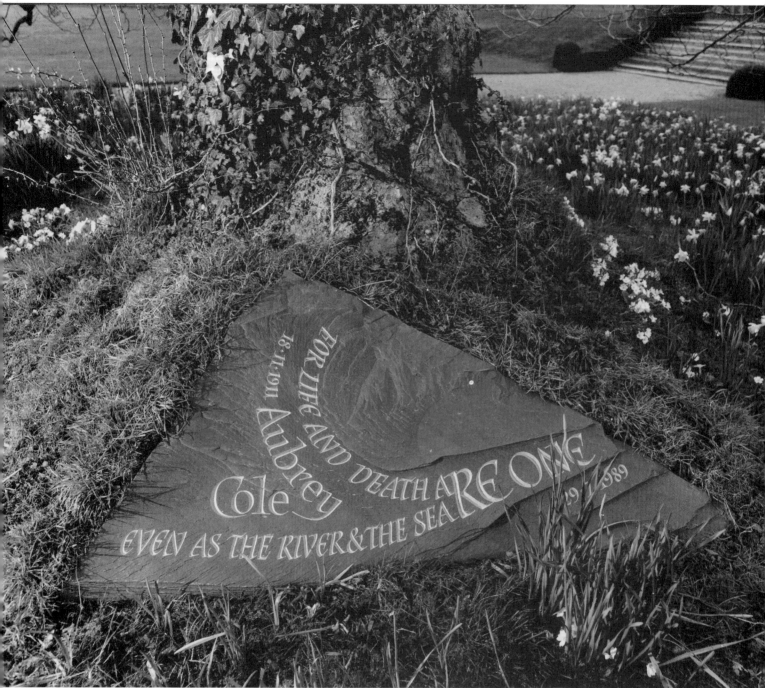

FOR LIFE AND DEATH ARE ONE
18·11·1911
Aubrey
Cole
EVEN AS THE RIVER & THE SEA ARE ONE
19·1·1989

DAVID HOLGATE

in contemporary art terms would be called an 'image and text work' and opens up for it a different range of possibilities. The choice of imagery can be very wide. Until the Reformation and the rise of literacy in England, people's deepest feelings were embodied in visual emblems. The practice of sacramental religion is dependent on symbols such as water, bread and wine, and some people would claim that certain symbols are so universal and deep in meaning as to be God-given.

The contemporary master of image and text is the Scottish poet Ian Hamilton Finlay, whose works are created through a process of collaboration with artists and craftsmen, many of whom are represented in this exhibition. They are often made for placing in an outdoor setting, as part of a garden; and while they cover a considerable range of subjects and moods, they are always thought-provoking and elegiac—a sort of generalised model for memorial art. One of his most recent works (with Andrew Whittle and

Peter Coats), and the first to be publicly visible in London, is at the Serpentine Gallery. Here, a round slate outside the entrance, inscribed with the names of trees and a quotation from the eighteenth-century philosopher Francis Hutcheson, has been made into a memorial to Princess Diana (although when designed it was intended that she would open it as Patron of the gallery). It will probably be the best memorial she will receive, and it is appropriate that it should be located so close to Kensington Palace which, in the first week of September 1997, became the site for so many spontaneous acts of commemoration. These were sincere but artless offerings. The professional skill of the artist and poet is not to personalise but to universalise without abstracting the emotion out of existence. The Cenotaph in Whitehall, on the other hand, designed by Sir Edwin Lutyens in 1919 as a public memorial to the dead of the first World War,

is a tremendously accomplished piece of design, but so abstract as almost to chill the emotions. Wearing emotion with dignity in public goes against the grain of modern culture and was something they managed better in the seventeenth century, before the separation of thought and feeling. We need to go back to Milton's *Lycidas* and Purcell's funeral music for Queen Mary to find pieces written for an occasion that carry a universal message through time. But there is every hope that, with the kind of changes in attitude that the Princess of Wales's death revealed, there is a new opportunity for those who use words and images professionally to provide objectified channels for the expression of public feeling. The humble but beautiful personal memorial is not just an archaic survival of obsolete beliefs, but the forerunner of a better understanding of our place in the world. ◆

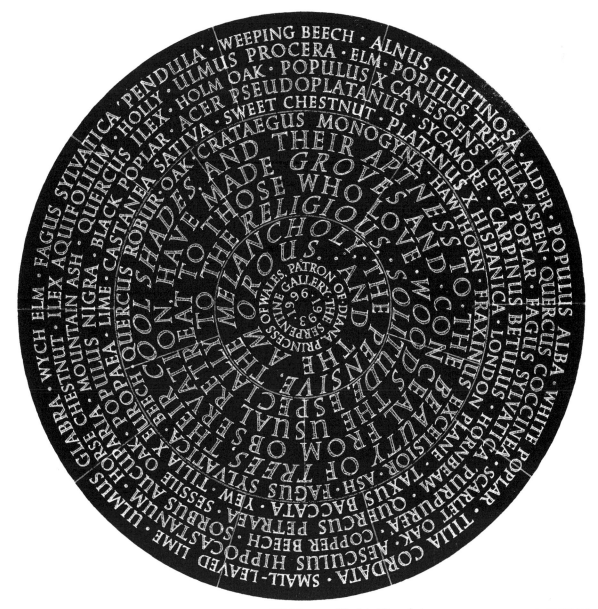

Contemporary Lettercutting

TOM PERKINS

This essay attempts to record briefly some of the prominent people involved in lettercarving in stone in Britain today. I am specifically concerned with those lettercarvers who work as artists either in one-man studios or in small workshops, not with the monumental mason's trade where the priorities are more likely to be economic rather than aesthetic, leading to a standardisation of design rather than an individual approach. Much could be gained on both sides through more contact and exchange of perspectives, but so far little has happened in this respect.

It is inevitable in a short survey that some lettercarvers of note will be left out, and I would not like it to be thought that only the people mentioned here are worthy of consideration. My main criteria for inclusion is a genuine engagement with letterform and a degree of individuation in the work. Lettercarvers undertake other types of work apart from the obvious one, in this context, of memorials. Most carved lettering is produced to commission. This can range in scale from a simple house number to a large sign on the side of a building spanning several metres, carved directly into the stone or, in some cases, brickwork. Plaques recording the opening of buildings or information about a particular place are still often required. Increasingly, many lettercarvers produce work of a more personal and experimental nature and there are now many opportunities to exhibit work of this kind, though compared with other crafts there are relatively few collectors of fine or experimental lettering.

Behind the whole area of lettercarving in Britain this century stands the dominant figure of Eric Gill (1882-1940). Gill managed to gain for lettercarving a place within the modern studio crafts and gave the craft a profile which enabled several of his assistants to carry fine lettercarving on into the Post-War era. Few lettercarvers working today would share entirely Gill's rather conservative and classical approach to carving letters. The influence of the freer approach to both letterform and composition of Gill's close friend David Jones (1895-1974) can be seen in much contemporary lettercarving. Indeed, the whole period

since the 1960s may come to be typified as the era of the 'free capital'. Other influences include the more sculptural and bold use of letterform found in the work of German carvers such as Sepp Jakob who co-authored the seminal work, *Schrift und Symbol,* an essential addition to any lettercarver's library.

Gill's best-known assistant was David Kindersley (1915-1995) who successfully carried forward the Gill tradition of finely-tuned classical forms into the second half of this century. Kindersley developed a wider palette of forms than his master, Gill and delighted particularly in the use of flourishes. He produced an ornamental approach to lettercarving reminiscent of eighteenth-century writing masters, sometimes covering the whole surface of his slates with elaborate flourishes. Kindersley is also responsible to a large extent for the popularity of slate amongst present-day lettercarvers. Slate is a fine-textured material, neither too hard nor too soft, that takes a well-defined letter. It also has excellent weathering properties, making it an ideal choice in many situations. The carver and lettercarver Kevin Cribb, son of one of Gill's principal assistants Laurie Cribb, worked alongside David Kindersley from his early days near Cambridge in the 1940s up to the 1980s. The very real contribution such men and women make to a workshop like David Kindersley's often goes unacknowledged, or is not taken properly into consideration when any assessment of a workshop's production is recorded.

The Kindersley workshop still continues in Cambridge under the able guidance of his widow and former assistant Lida Lopes Cardozo who has made her own characteristic versions of classical Roman capitals and lower case italics. Some of the more recent lettercarvers to come through the David Kindersley Workshop include, among many others, Eric Marland (who now works at The Carving Workshop and recently carried out an important commission for Pembroke College, Cambridge) and Bettina Furnée who now has her own workshop.
Another Gill assistant who has gone on to distinguish himself is the German-born Ralph Beyer. Beyer has made a compressed and

squarish form of capital very much his own. He readily acknowledges the freer approach to letterform and composition used by David Jones, notably on the 'Tablets of the Word' at Coventry Cathedral—one of the most striking uses of lettercarving on the grand scale in Britain this century. The following words of Beyer are worth quoting in this context: 'For freely-created and freely-composed lettering there are no rules: the meaning and nature of the words will make their own demands. The future holds untold possibilities: we need the word, the graphic word, the word transcribed creatively, and in a public context'.

John Skelton, Gill's nephew, whose apprentice-ship to Gill was cut short by Gill's death in 1940, has lived and worked near Ditchling in Sussex for most of his life. All through his career his lettering has had a precision and verve, and it often seems as if the freeform shapes in some modern sculpture have found their way into his letterforms. Particularly good examples of Skelton's carved lettering can be seen in the crypt of St Paul's Cathedral alongside the work of many other fine lettercarvers. Here it is appro-priate to mention one of his most talented long-term assistants, Jack Trowbridge, who now lives and works as a lettercarver and jeweller in Cornwall. Trowbridge has a natural affinity with letterforms and an ability to make fresh interpretations of tra-ditional forms. He has not received the recogni-tion he deserves in this field. Skelton, in a recent video about lettercarving, has generously acknowledged the influence of his former pupil.

The stonecarver Michael Biggs (1928-1993) who was born in Stockport and lived most of his life in Dublin, was a friend and contemporary of John Skelton. They met while Biggs was working with Joseph Cribb, Gill's first apprentice, on Ditchling Common in the 1940s. Although better-known in Ireland as a liturgical artist and sculptor, Biggs managed to evolve a distinct identity of his own as a lettercarver through his exploration of Irish vernacular forms which he adapted very success-fully for contemporary use. He carried out some very large public commissions in Ireland and his work should be better known than it is at present.

The Cambridge-based printer and lettercarver, Will Carter has made a distinguished contribu-tion to lettercarving this century. Although work-ing mainly as a printer, founding and running the Rampant Lions Press (now continued by his son,

Sebastian) Carter has carried out many inscrip-tional projects throughout his career. He has evolved a distinctive form of Roman capital—a kind of 'beefed up' Trajan letter, which he calls, appropriately enough, Carter's Caps—and all his letters have a soundness of construction and a familiarity with calligraphic form, rare in carved lettering in Britain. Carter started carving letters after attending evening classes with David Kinder-sley early in his career. The two became friends and went on to collaborate on the design of a typeface, Octavian, for Monotype. Interest-ingly enough, Carter came into contact with Paul Koch, son of the great German calligrapher Rudolf Koch and also the incomparable Her-mann Zapf of Germany in the late 1930s.

Another long-established Cambridge lettercarver is Keith Bailey. He studied sculpture at Liverpool and Manchester Schools of Art and subsequently worked casting sculpture in a foundry. Through attending classes at the City and Guilds of Lon-don School of Art, he was asked by David Kinder-sley to assist on a large war memorial for the American Cemetery near Cambridge. Bailey has had his own workshop in and around Cambridge for the last 40 years or so, and for many years has collaborated on a number of jobs with the Scot-tish poet, Ian Hamilton Finlay. He has also assisted Richard Kindersley on a number of important commissions. Bailey is very versatile—'a sculptor at heart'—and over several decades has contributed a varied and able body of work to lettercarving.

Another most versatile letterer of recent years is Michael Harvey, who started out learning letter-carving in stone as an assistant to Reynolds Stone in the 1950s. Stone's real contribution was in the field of wood engraving, though he did carry out some carved inscriptions of note. Harvey went on to establish a reputation as a successful designer of lettered book-jackets, which experience he now puts to good use in computer type design. Alongside his graphic work, he has continued to produce carved inscriptions of a high quality. He has also collaborated with Ian Hamilton Finlay. In 1990, Harvey produced one of his most impor-tant inscriptional projects, carving large-scale let-ters for the extension of the National Gallery in London, assisted by Brenda Berman and Annet Stirling of Incisive Letterwork.

Another versatile designer and craftsman who has contributed to lettercarving is Michael Renton.

CHARLES SMITH

contributed to lettercarving is Michael Renton. Renton is a keen admirer of Eric Gill. Whilst working from a solid, traditional base, he has produced clearly-recognisable forms of his own which he carves or paints with equal facility. He studied lettering with William Sharpington (well-known for his brush lettering) at the City and Guilds of London Art School where he was introduced to lettercarving in stone. He also has a high reputation as a wood engraver and has designed, amongst many other things, the letterhead for *Memorials by Artists*. Mention here should be made of the Welsh calligrapher and lettercarver Ieuan Rees who was taught calligraphy by Donald Jackson of Camberwell School of Arts and Crafts before gaining a place at the Royal College of Art. His work, not surprisingly, often shows a strong calligraphic influence, with a liking for circular compositions of text—for example, his memorial to Lewis Carroll in Poet's Corner at Westminster Abbey. Rees, a charismatic teacher, has conducted many workshops on calligraphy and lettering on both sides of the Atlantic, and has inspired many people with his sincere and knowledgeable approach to making letters.

A lettercarver whose work has very individual qualities is Charles Smith. He started out working for a firm of monumental masons in the North East before branching out as a freelance lettercarver, eventually arriving at Reigate School of Art and Design in the mid-seventies on the calligraphy course. Smith has a preference for riven or uneven surfaces combined with freely-designed capitals with an angular and calligraphic quality, sometimes combined with decorative borders. He has pursued his own course, resisting more formal approaches to lettercarving. This has perhaps limited wider appreciation of his work.

Richard Kindersley, David Kindersley's son, trained in his father's workshop in the 1950s and set up his own studio in Kennington in the 1960s. He has a particular interest in lettering in association with architecture which has led to many commissions for large-scale carving of letters directly into the fabric of the building, in brick as well as stone. Richard Kindersley has helped many people to make a start with lettercarving, as well as providing opportunities for more experienced makers to hone and improve their skills. Many of these have gone on to establish careers for themselves. Among them are such names as Tom Perkins, Alec Peever, Annet Stirling, Sarah More and Gary Breeze.

Tom Perkins arrived at Richard Kindersley's studio in 1976 after two years' calligraphy at Reigate School of Art and Design. He manages to infuse his drawn and carved letters with a subtle calligraphic influence and consequent sense of rhythm and movement, and has evolved a modern form of capital letters which intuitively blends elements from many sources into a harmonious whole. As the influential calligrapher and teacher, Ann Camp has written, 'He has successfully bridged the gulf between two distinct lettering arts and combined the skills acquired from both.' He has recently carried out a carved inscription spanning several metres in red sandstone on the new extension and Opera School for the Royal Scottish Academy of Music and Drama. Perkins has introduced many people to lettercarving through his teaching. Some of these students have subsequently gone on to train with him in his workshop and have established, or are establishing themselves as lettercarvers. These include John Nash, Sue Hufton, John Neilson and Gareth Colgan.

John Nash, born in the US, studied calligraphy at Roehampton in the 1980s and has a strong preference for traditional work. Over the last decade he has carried out work for Ian Hamilton Finlay as well as other commissions, including a memorial in Westminster Abbey. Gareth Colgan and John Neilson were also trained in calligraphy at Roehampton. Although relative newcomers to lettercarving, they have nevertheless carried out a number of large commissions, Colgan in Dublin and Neilson around his home area on the Welsh Borders. Their sensitive and perceptive work is worth looking out for in the future.

The lettercarving course at the City & Guilds of London Art School (unfortunately now discontinued), has provided quite a few lettercarvers with a start. Alec Peever and Annet Stirling came through this course before starting work with Richard Kindersley. Peever has inherited Richard Kindersley's interest in working in a broad range of materials and also in lettering for architecture. In a recent statement he says '… much of my work over twenty years has been to explore three-dimensional possibilities in a variety of materials, with the precise intention of applying these letters to architecture'. Peever feels happiest working to commission, where things have a definite purpose, and has developed his carving skills in areas other than lettering, combining his letterforms with relief-

carving on memorial stones to good effect. In 1988, Annet Stirling and Brenda Berman (another former City & Guilds student) formed a partnership called Incisive Letterwork. They have collaborated on some considerable projects with Ian Hamilton Finlay, including large letters cut out of granite and set into the ground in a square between two art galleries in Hamburg. They have benefitted greatly from the books on lettering by Nicolete Gray, which advocate a more experimental approach to letterform than the methods of both Edward Johnston and Eric Gill. In a recent article they quoted the sub-title of one of Gray's books, *Creative Experiment and Letter Identity* as summing up many of their own lettering preoccupations.

After studying stonecarving at the City & Guilds of London Art School, Sarah More worked for some time with John Skelton and also assisted Richard Kindersley, going on to set up her own workshop in Avon in the 1980s. She has a range of carving skills of which lettering is one aspect. Her work can be seen at Westminster and Romsey Abbeys and Hyde Park. She is particularly interested in carved lettering in landscape settings.

A carver who has made an impact on the letter-carving scene recently is Gary Breeze. After studying graphic design, he assisted the Norwich-based carver and letterer, David Holgate. Breeze makes effective use of the computer in some of his letter-design work for carving and has recently carried out a major commission for the Justiciary Building in Glasgow, consisting of a frieze juxtaposing incised and raised forms.

David Holgate is a contemporary of Richard Kindersley and trained at David Kindersley's workshop in the fifties at the same time as Richard. Holgate is a very skilled low-relief carver and combines this work with lettering on many of his memorials. He is one of the few people who brushes his letters directly onto the stone, instead of the more usual practice of drawing them out first with a pencil. Another lettercarver of note who trained with David Holgate, is Nicholas Sloan. He has collaborated with Ian Hamilton Finlay on many occasions, including some large-scale projects which he seems to relish. His other great interests are printing and engraving, and running his own printing concern, the Parrett Press. Not unexpectedly, his enthusiasm for the typographic form often flows into his carved letters in stone. There is no doubt that lettercarv-ing in stone, practised as a studio craft by designer-craftsmen, is on the increase compared with twenty years ago, despite the closure of full-time courses in lettering. Certainly the founding of *Memorials by Artists* by Harriet Frazer ten years ago has had a beneficial effect, focusing attention on a craft long neglected within the broader context of contemporary crafts. I would not have thought it possible, when I started lettercarving twenty years ago, that there would be exhibitions of carved lettering in Cork Street. Rupert Otten, a director of The Gallery in Cork Street and owner of Wolseley Fine Arts in Notting Hill Gate is to be congratulated for showing lettercarving in this way and demonstrating a demand for this kind of work, if presented in the right way.

The portents for well-designed lettercarving, moving into the next century, look encouraging. The more life becomes mechanised and computerised, the more we feel the need for the balancing effects of humane workmanship inour environment. There may no longer be an economic or functional argument for the making of objects with simple tools by hand, but the psychological advantages, both to the maker and the viewer, are incalculable. Our public spaces within and around buildings, parks and gardens, churchyards and cemeteries, could be greatly enriched by the use of hand-carved lettering in ways that have scarcely been explored.

Exhibitions such as this one, inspired by Harriet Frazer and curated by *Memorials by Artists*, have a major part to play in encouraging people to see letterforms in a different way, transcending the purely functional. The great German calligrapher, Rudolf Koch expresses very well the diversity possible in making inscriptions when he says that within the apparently restricted compass of lettering '...there is a rich immeasurable source of life, inexhaustible and unfathomable in its forms, movements, contrasts and proportions'. If you look carefully at the exhibits, you begin to enter this rich and varied world of lettermaking and see something of the differing personalities at work behind the artefacts. A skilled and experienced lettercarver will develop forms as personal to himself as his own handwriting. It is to be hoped that this exhibition will draw the viewer into a closer relationship with the world of carefully and sensitively formed letters in stone. We need the 'living letter' now more than ever. ◆

At last he rose,
and twitched
his mantle blue:
Tomorrow to
fresh woods
& pastures new.

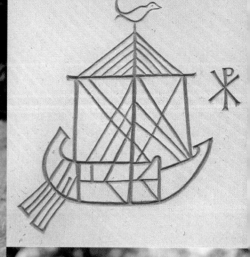

WORKE
TOGETHER

EAT BREAD
TOGETHER
GERRARD
WINSTANLEY

Finic
Cats
All

Judy 1984
BEST 2 MOTHER
Charlie 1985
Minstrel 1987
Fluff 1987
Blackie 1987
Smudger 1989
LOST AND FOUND THE VIC'S HOME
Penny 1991
& PUT TO SLEEP

OF
A
CERTAINTY
THE
MAN
WHO
CAN
SEE
ALL
CREATURES
IN
HIMSELF

HIMSELF
IN
ALL
CREATURES
KNOWS
NO
SORROW

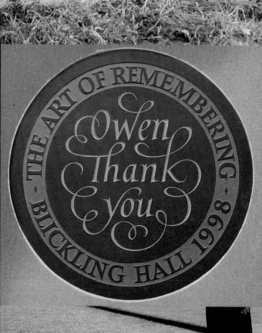

THE ART OF REMEMBERING
Owen
Thank
you
BLICKLING HALL 1998

The Art of Remembering

CATALOGUE AND ARTISTS' STATEMENTS

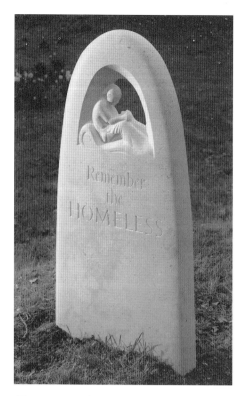

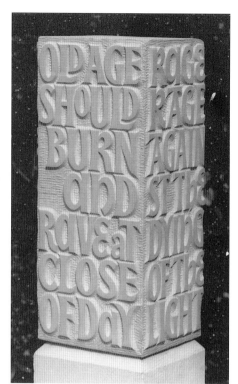

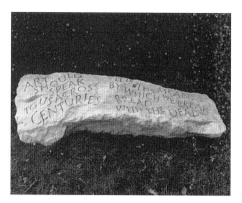

KEITH BAILEY

(18) *Wild Stone*
Portland Stone
54 x 22 (x 9 at highest point) inches

I like unusual stones and it's an extra challenge to work on an uneven surface. I find it more interesting than doing ordinary conventional things. It's a question of getting the right stone at the right time for the right quotation.

GEOFFREY ALDRED

(23) *Stone to the homeless*
Griffeton Wood Stone 48 x 24 x 4 inches

The inspiration for this work was Yorkie Greaves, a seventy-four year old homeless man who died in Kentish Town in 1996, having lived on a park bench for fifteen years.

The spontaneous tributes by local people as reported in Oliver Gillie's article in The *Independent* prompted me to design a memorial to all the homeless dead, but then I recognised a paradox that made them incompatible. Yorkie chose the outdoors and had a life unlike most who find themselves on the streets. The average life expectancy of rough sleepers is forty two years compared with a national average of seventy six. Many die each year in their twenties and thirties, often anonymously and brutally. These deaths receive little attention. I wanted to signify the pity and the waste of young lives with this memorial stone.

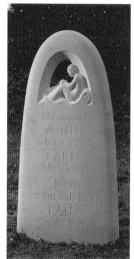

JOHN ANDREW

(13) *For Helene*
Caen Stone 46 x 10 x 9 inches

The poem-column idea I have had for a long time. Having worked a great deal in relief and with incised lettering the idea of working in the round, the real third dimension, is very appealing but lack of time and relevant opportunity has always stopped me from doing anything about it.

The tragic death of a very great friend of my wife and myself made a very relevant reason.

Helene was tough-minded, highly intelligent and had a great sense of humour. For her funeral service, which she planned in detail herself, she asked me to read Dylan Thomas's 'Do not go gentle into that good night'. As she had been a witness at our wedding she already knew what a great cry-baby I am and knowing her sense of humour I'm sure she had a bet on that I would not be able to do it without crying. She was right.

I would love to see and do more poem columns. I think the short Japanese form, the haiku, lends itself very well to this idea. As with the Dylan Thomas poem they encapsulate so much in few words. I believe that the grace notes good memorials provide are genuinely life-enhancing and the best and most enduring tribute we can leave behind when we die.

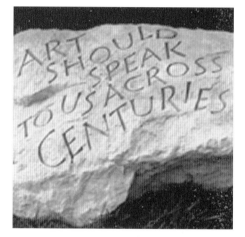

I didn't want to do a fictitious memorial for this show. I suddenly came across this quotation by W H Auden. I was getting desperate to find something that appertained to death without being morbid about it and I like the opportunity for doing wild stones for a garden setting.

RALPH BEYER AND PETER FOSTER

(42) *Early Christian Symbols*

These symbols seemed right for this exhibition because they all express the joyful aspect of death. They are painted Earth Red—Catacomb Red. This colour was used in most of the inscriptions by the Romans.

RALPH BEYER
Portland stone 24 x 21 x 2 inches
(a) Two Shoes (symbol of departure from life or beginning of 'the journey into the other country')
(b) Sailing Ship with Bird and Chi-Rho

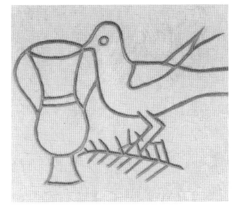

(the bird is the symbol of the soul)
PETER FOSTER
Portland Stone 28 x 17 x 2 inches
(a) Chi-Rho between two birds sitting on branches (Vatican Gallery)
(b) Bird with palm branch and water jug (refrigerium is symbol of Heavenly refreshment).

Peter Foster: The idea for the two catacomb symbols came from Ralph Beyer who is also carving two for the exhibition and it is to be a joint venture. We have a joint appreciation and love of these early Christian symbols and I have worked with Ralph Beyer on them before. What I especially love about them is their freshness, simplicity and mystery.

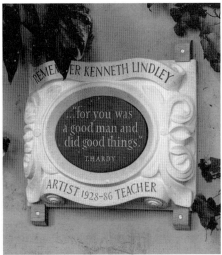

REG BOULTON

(37) *Memorial to Kenneth Lindlay*
Purbeck Stone and Welsh Slate
12 x 15 x 3 inches

My design is the fusion of three concerns. First my respect for a friend whose painting and engraving I loved and whose enthusiasms I admired. Secondly my enjoyment of the three-dimensional forms we see in Baroque design and the possibility of making something more three-dimensional than usual. Thirdly I took the opportunity of using this quotation from the last few lines of 'The Woodlanders' by Thomas Hardy—an epitaph I have always found deeply moving in its simplicity.

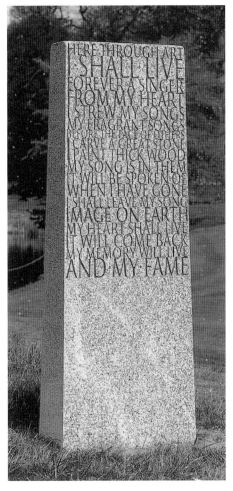

GARY BREEZE

(1) *Song Stone*
Cornish Silver Grey Granite
60 x 22 x 11 inches

An extract from an early letter to Harriet Frazer about the 'Song Stone':

Enclosed is a sketch of an idea I have had in the back of my mind for about four years! It is an ancient Aztec song, and in the 'big-headedness' of my own ideal little world, it would be my epitaph. The sentiments are really too grand for me although they work so well for all artists, be they musician, painter, sculptor or writer; a sort of 'Memorial to the Unknown Artist'. It suddenly seemed appropriate for this show somehow and I would like to make it…quite big?

'Song Stone' is made from Cornish Granite and is an attempt to combine the techniques employed by many trade monumental masons with the careful design most commonly associated with the designer/craftsperson. The lettering is sand-blasted through a rubber stencil which was cut by a computer-driven knife. The computer 'font', drawn specifically for this purpose, I called 'Gabriel' and is designed with different weights for each letter size to maintain consistency in texture throughout the layout.

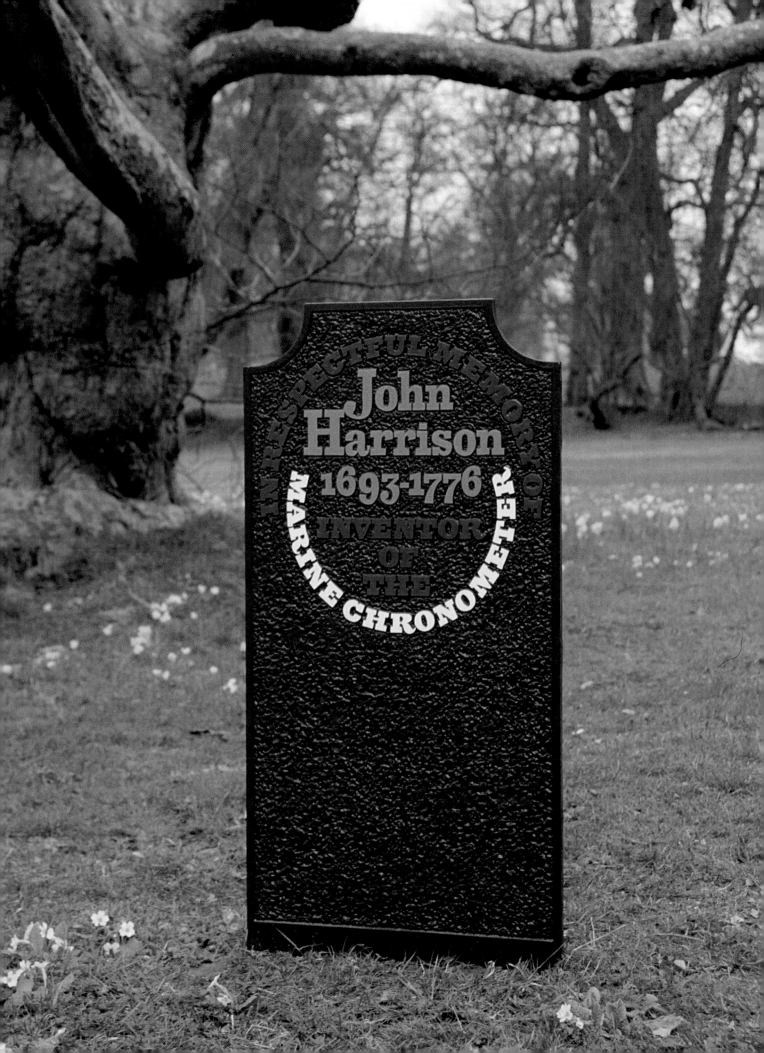

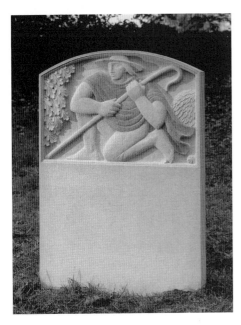

HARRY BROCKWAY

(25) *Headstone with Shepherd*
Headstone in Portland Limestone
600 x 90 x 1000mm

Front: Relief carving of a shepherd rising to his feet.

Reverse: Inscribed letters quoting the last two lines of John Milton's *Lycidas*.
In 1997 I was commissioned to illustrate John Milton's poem *Lycidas*—Elegy on a friend drowned in the Irish Channel. I was impressed by the poem and thought the famous closing lines would be very suitable for a headstone. The image of the shepherd is one I have used several times in my work over the last ten years.

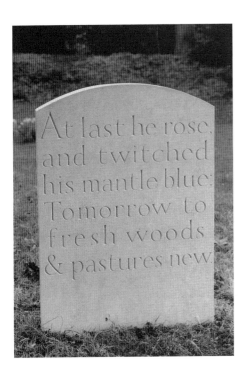

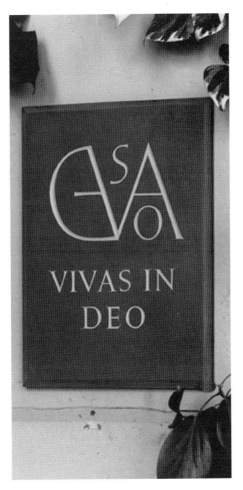

KEVIN CRIBB

(38) *Monogram*
Welsh Slate 19.5 x 14 x 1 inches

I first came across this early Christian 'monogram' when I was asked by the painter Peter Campbell to design and make a headstone to his mother and to incorporate the symbol.

VIVAS IN DEO (God be with you) was used as an expression of good will in early Christian letters.

This information is taken from *The Book of Signs* by Rudolf Koch (published by Dover Publications in New York).

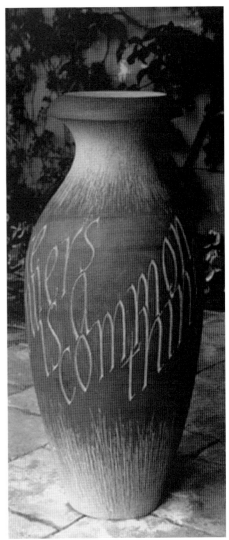

DAVID CROWE

(32) *Large Vase*
Kirkstone Sea Green Slate
800 x 360mm (at widest)

I'd been wanting to make a vase or bowl ever since a visit to Japan, where their shape and form have such an ethereal quality. So this exhibition was a perfect opportunity to explore the shape of a vase and the relationship it could have with the carved letterforms.

I had been considering the shape of the vase for some time, but needed suitable wording to tie in with the organic feel I wanted the whole piece to have. It was while looking through my mum's old autograph book one evening, that I found an Oriental proverb, written by her English teacher and really felt I'd found something that represented a partnership between the tangible and spiritual.

*'To raise flowers is a common thing
God alone gives them fragrance'*

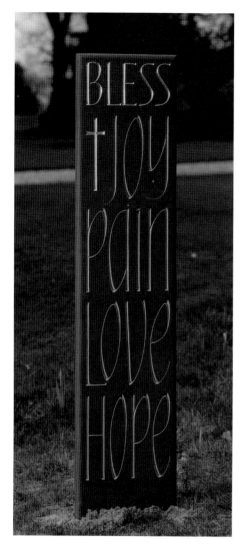

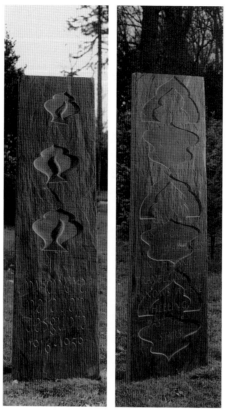

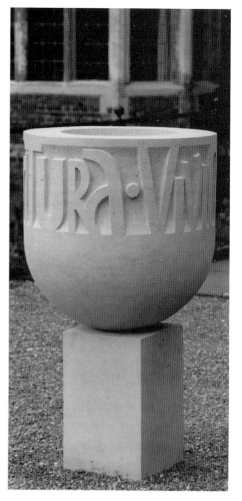

ANDREW DAISH
(46) *Meditation Marker*
Welsh Slate 48 x 11 x 1.25 inches

I have learned from both personal experience and through the experiences of clients from *Memorials by Artists* that, when you lose a much loved person, you suddenly become very aware of your own mortality and enter a state of reflection. We realise that our lives consist of contrasts—to understand joy we have to experience pain and similarly to understand love we have to experience rejection and so on. A grave marker can be a tangible way of expressing these feelings in the form of a beautifully shaped slate or stone and with letters that are carved with care. The grave can then become a place of beauty, reflection, meditation and stillness.

With these thoughts in mind, I decided to design a slate marker that celebrated or 'Blessed' four of the most obvious feelings we experience in life, feelings that make us both human and mortal

JOHN DAS GUPTA
(16) *Lantern Headstone*
Riven Welsh Slate 60 x 20 x 2 inches

The stone is to my father, a Bengali, who died 39 years ago in Darjeeling and was cremated there in the customary manner. I felt the design should strongly reflect his Indian origins, yet take some account of the memorial traditions that exist here.

The front of the stone carries the biographical facts and shows a lantern motif; an idea taken from a television programme about the kite-flying season in India. This season is traditionally ended with the release of a delicate paper lantern containing a tiny flame. It drifts precariously into the evening sky, a vulnerable yet potent beacon which seemingly captivates the crowd of onlookers by its strange aura of magic.

The reverse of the stone is a more complex arrangement of English and Bengali. These are short passages from poems by Rabindranath Tagore whose work, especially folk-songs, is still loved throughout Bengal. These combined texts overlay an abstracted pattern, itself a play on image and ground, which covers the entire surface.

BELINDA EADE
(53) *Vessel with Inscription:*
INTER PERITURA VIVIMUS
(we live amongst things that will perish)
Bath Stone 1200 x 650mm diameter

To carve words in stone is to ask someone to stop and contemplate these words. The vessel has always been symbolic of life and ritual. Its image is associated with water—the source of life, and also with preserving the ashes of the deceased. It has a shape of strength and simplicity.

Here, with its inscription, it is speaking of seasonal change; life's continual rebirth and renewal.

The words, taken out of their original context, adopt a meaning of their own; the manifold interpretations being inspired as much by the rhythms of the sounds, or the contemplative nature of the words, as by the patterns of design in the changed stone.

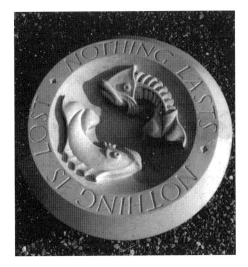

MARK EVANS

(49) *Nothing Lasts, Nothing is lost*
Griffeton Wood stone (Derbyshire Limestone) 600 x 200mm

This bowl is the second version, very similar to one which was made a few years ago, but slightly larger and carved from Derbyshire limestone instead of Portland. At that time, a small series of fish bowls was made, often with text running around the edge. In this case the text was found not in a book of poetry, a song or a Zen koan, but was seen spray-painted, not particularly skilfully, on the side of a railway bridge. In five words it seems to say something complete and at the same time pleasingly ambiguous.

There are circumstances when it is a painful and brutal truth that 'nothing lasts', and others when it is something to be hoped and prayed for. Similarly, there are times when the feeling that 'nothing is lost' is a burden to carry and others when it is a source of great comfort. It is a paradoxical little statement that seems to echo the unfathomably enigmatic relationship that life has with death.

The fish speak for themselves.

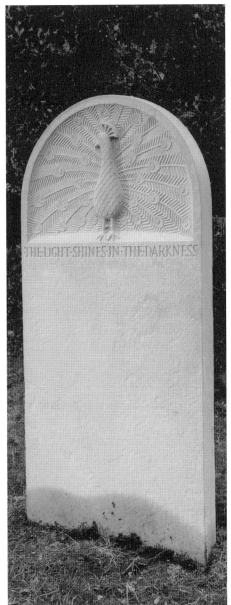

PETER FOSTER

(27) *Headstone with peacock*
White Mansfield 32 x 19 x 2 inches

The idea for carving a peacock came from a need to show relief carving in stone in the context of facing up to death with hope in the resurrection; and shedding a ray of light and hope through the warmth of carved stone. The peacock with quotation below 'The light shines in the darkness' instructs us about the light that came into the world in Jesus.

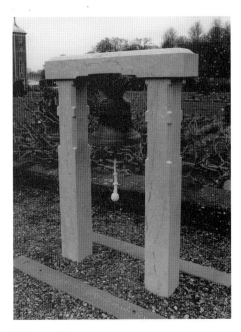

MARK FRITH

(45) *The Sound of a Bell*
Base: Green Slate—Frame: Lioz pp (Portuguese Marble)

"No man is an *Iland*, intire of it selfe; every man is a peece
 of the *Continent*, a part of the *maine*; if a Clod bee washed
 away by the Sea, Europe is the less, as well as if a
 Promontorie were, as well as if a *Mannor* of thy *friends* or of
 thine owne were; any mans death *diminishes* me, because I
 am involved in *Mankinde*; and therefore never send to
 know for whom the bell tolls; It tolls for *thee.*"

JOHN DONNE
Devotions upon Emergent Occasions

Throughout the world sound is used to bring our attention to the moment, from the voice in chants, to the chimes of bells and cymbals. The clarity of a single note helps to clear our mind, while the silence that surrounds it gives a time of contemplation and meditation. The resonance carries our wishes and aspirations out to the world, as the prayers of Tibetan prayer flags travel in the wind. Memorials provide a tactile object for us to be with our own thoughts, and being able to strike the bell allows us to enter at our will.

The bell is a familiar symbol to us; its universal nature pays recognition to the collective group and beyond 'To those Unknown'. The sound not only denotes a passing but can also give thanks in celebration, looking forward, announcing both arrival and the start of a journey.

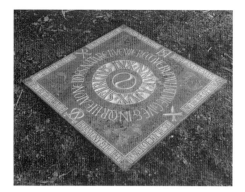

Peter Furlonger

(22) *Lux Natura Lux Spiritus*
Green Slate 36 x 36 x .75 inches

The design for this carving evolved over a period of years during which I worked on various lettercutting projects whose central concern was the creation of strongly-patterned sculptural and expressive lettering. Letterforms of varying texture, scale and technical rendering, combining into 'images' rather than inscriptions; letter design which is intended to be 'seen' rather than 'read'.

I feel that my designs should work visually first, and only secondarily should the text be deciphered for its literal meaning. The visual configuration, the design, is its meaning, to which the text gives a key.

The evolution of these thoughts coincided both with a period of personal loss and grieving; and also the development of my work as a calligrapher/glass-engraver, both of which have had, I believe, considerable bearing on my work as a lettercarver.

Bettina Furnée

(17) *Mourir au Printemps*
Welsh Slate 24 x 18 and 16 x 16 inches

The pair of Welsh slate markers is conceived as a memorial to those who died too young. Maybe we grieve most painfully for a life lost before it could ever be fulfilled.

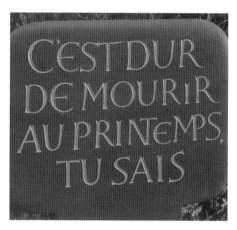

I found words for the memorial which carry out the cruelty, disbelief and pain of an untimely separation: 'C'est dur de mourir au printemps tu sais' (You know, it is hard to die in spring), and which illuminate the need for a loving farewell: 'Adieu, je t'aime bien tu sais' (Adieu; I love you, you know). The words are from a song, Le Moribond, by Jacques Brel.

I aspired to make a memorial which celebrates the notion that also in immaturity or littleness lies a life which is self possessed. The memorial is owned by and made for the living as a symbol of their continuing love, but the person we grieve for, although belonging to us, was never owned by anyone but themselves.

Jon Gibbs

(8) *'Be Still' Memorial*
Griffeton Wood Stone 750 x 250mm

All of my lettering is a response to words. These words 'Be still and know that I am God' could not be stronger. They offer comfort, strength, reassurance and hope to the reader, and protection of the soul remembered.

Aesthetically I am drawn to simplicity and that which is 'of its age'. My original idea centred on the contrast of two different stones, but the design process stripped it down to a single piece of pale stone, tall and narrow (redolent of the menhirs of ancient times), with stained letters.

I am critical of the single-sided approach to memorials in as much as it seems to waste an opportunity to either be more sculptural in approach, or simply to separate the pragmatism of names and dates etc from the spirituality, beauty and meaning of fine words. In this example, this separation could be effected by adding names and dates etc. to the edges.

I foresee the time when people will reject the regulations and uniformity of commercial and municipal cemeteries; and will have pleasing artefacts in their own gardens to remind them of their loved ones, as I have with a memorial for my father.

I like to think that this work would enhance a garden, and perhaps act as a focal point for a family's fond memories.

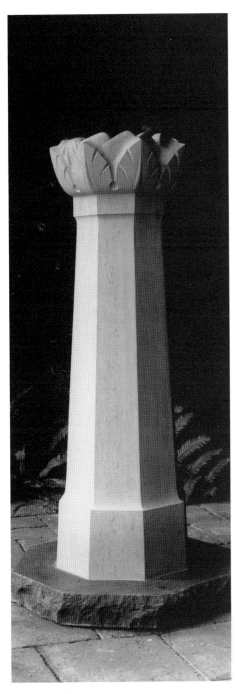

HARRY GRAY
(40) *Font Stone*
Ancaster Limestone 1100 x 700mm

Remembering our arrival in the world
was the inspiration for this font stone.
On the faces of the octagonal column the
initials and birthday of the baptised would
be carved, the lettering growing gradually
downward as new lives are celebrated.
The cupped hands within leaves at the
column's top symbolise something
precious held—the water of life.

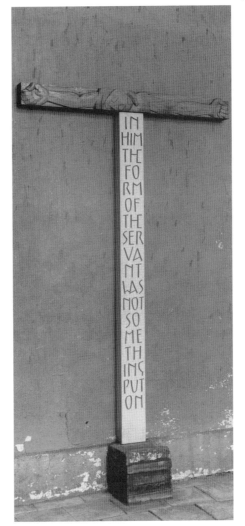

CHARLES GURREY
(31) *Crucifix*
Portland Stone and English Oak
66 x 44 inches

A crucifix seems the ultimate memorial.

The exhibit grew out of my response to
the biblical quotation: Philippians 2. v.7.
This figures centrally in the *Philosophical
Fragments* of Soren Kirkegaard and is
philosophically and religiously compelling.
I had to find an image for this.

The dual nature of Christ is there in the
two materials brought together as a Tau
cross. The Portland limestone upright with
incised lettering supports a laminated
carved beam of English Oak.

Churches offer so many natural
opportunities for the doing of memorial
work which can serve a common purpose.
A pulpit crucifix and large Paschal candle
stand have both come to me, in this way,
as commissions.

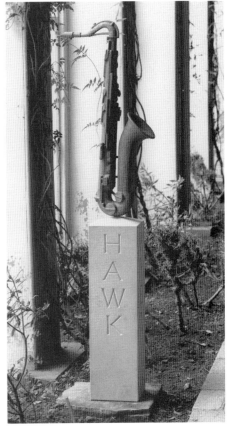

MICHAEL HARVEY
(39) *Four Tenors*
Hardwood with Portland Stone base
1800 x 250 x 250mm

Thinking about what I would like to carve
for my own garden I imagined a stone bird
bath, with a decorative bird in low relief.
I wanted words too, and in a flash I had
them: the name CHARLIE PARKER, the
great jazz musician known as Bird. So my
carving became a Bird Bath.

I began to invent other jazz-related
projects, especially one incorporating a
tenor saxophone which evolved into the
design exhibited here, Four Tenors.
The stone base is inscribed with the names
of four masters of the tenor saxophone:
HAWK (Coleman Hawkins); PREZ (Lester
Young); ZOOT (Zoot Sims); GETZ (Stan
Getz). Now a Dorset garden will contain a
monument to these American jazzmen,
the carved wood saxophone will weather,
imitating their battle-worn 'axes' (as they
called their instruments) through which
they breathed passion, tenderness and joy.

Harriet Frazer writes: Speaking to Michael
on the telephone in February while he was
working on his piece: 'I haven't done
serious wood carving since 1956/57 and
now for this I'm doing it again. It's very
exciting. I'm having to re-learn.'

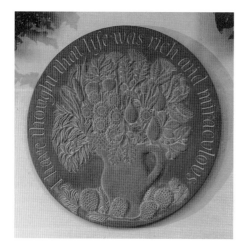

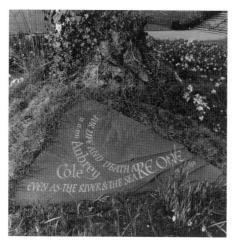

JOE HEMMING
(35) *Soph's Garden Memorial*
Welsh Slate 23 inches diameter

Harriet Frazer writes: Joe rang me one day in 1993. 'I've made something for you. It's about the size of a dustbin lid. I want to put some lettering on it. I was wondering about 'Seasons of Mists and mellow fruit-fulness'.

At the time I had been thinking a lot about my stepdaughter Sophie's stone and wishing we had had some of the words from her last letter to us inscribed on the

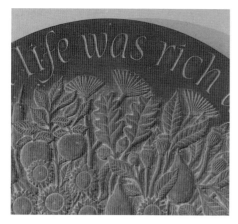

back of her stone. I asked Joe if he thought her words 'I have thought that life was rich and miraculous' would fit and work with the carving, I had no idea at the time what he had designed. He said, 'I think they'd fit amazingly well'.

Joe decided not to write anything for the catalogue himself so I rang him and asked him how the whole thing came about. 'I had one spare bit of slate in the workshop. I wanted to make something lovely and carved it into a round but then it had to sit in the workshop for about 18 months. I was at a loose end in between commissions at the time and I wanted to make a gift for you. And I love jugs of flowers'.

DAVID HOLGATE
(6) *Suffolk Garden Piece*
Riven Welsh Slate 1500cm x 650cm x 30cm

This piece was commissioned by Mrs Rae Cole to commemorate and celebrate the life of her husband Aubrey Cole. Her feelings were that she would much prefer a garden piece to a headstone. To this end I selected this slate boulder from a hillside in Wales, whilst collecting material for other commissions. Rae specified the text but otherwise gave an absolutely unconditional free hand for me to choose a piece of suitable stone—to react to it as I deemed fit—to lay out and design the text to suit the stone and its form, and to engrave it. All without seeing any design or concept sketches.

This level of trust is, in fact, rare but was the only way an 'organic' piece like this could come about, for the ideas about the man, the text, the stone texture, and the concrete poetry of the design could only come together by working directly on the stone and its shape. The letters were laid out free-hand on the stone using one-stroke brushes and watercolour, the first ideas being in a faint colour followed by progressively refined versions in deeper colours. After incising the letters the water colour was washed off. This is exactly the same technique as was used by Greek and Roman lettercarvers.

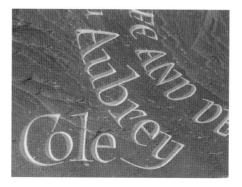

INCISIVE LETTERWORK (ANNET STIRLING AND BRENDA BERMAN)
(4) '*...for Linnaeus*'
Purbeck Cap Stone 4 square metres

Stone itself is part of the continuum whether used straight from the ground in rough pieces or worked and smoothed by masons. Botanical and zoological structures are part of the history of stone.

In choosing to commemorate Linnaeus, famous for his methods of botanical classification, we are conscious of the forces of both order and chaos which make up the earth's pattern and in our work we try to interpret some of these.

MARTIN JENNINGS
(2) *Text from Ecclesiastes*
Riven Westmoreland Slate
60 x 13 x 1 inch

When someone comes to my workshop to commission a gravestone we discuss with great care the way the stone will look to suit the person who has died. This care reflects the incomparable value we place on an individual life. The collaborative artistic endeavour, enhancing this sense of value, contributes to the process of consolation.

A very different form of consolation is offered from the other end of the philosophical telescope. The author of Ecclesiastes observes the disregard paid by the natural world to the demise of its individual members. Generation by generation we depart, taking our individuality with us. Seen in this way, personal anxiety over extinction loses its painful isolation, its power to overwhelm. Private grief finds its place in the river of life and death.

When I drew up this inscription, I had in the back of my mind that the stone would be suitable for a churchyard, perhaps set up in an area dedicated not for personal plots but for the general scattering of ashes. I proposed this locally but was politely discouraged in the idea. The inscription did not apparently express sufficient Christian hope. But people with different and varied beliefs come to churchyards looking for echoes and answers in their musings about death. The churchyard, if it is to respond, needs to offer consolation with a broad and generous philosophical reach.

BEN JONES
(50) *Analemmatic Sundial*
York Stone 13 feet wide

There are a number of sundial forms that require the viewer to work the dial in some way in order to show the time. An analemmatic dial is one such form. Smaller versions have a moveable gnomon but on a larger dial it is the viewer's own shadow that points to the hour.

Analemmatic dials can be set flat into a lawn, paved area or children's playground leaving nothing to trip over, bend or break off.

The hours can also be marked by posts, boulders or perhaps an ellipse of seats. The hour stones and centre scale provide a number of settings for inscriptions. To use the dial, stand with your toes on the correct date on the centre scale then face your shadow which should now be pointing to the hour.

Sun time differs from clock time by small and varying amounts through the year. To convert sun time into watch time use the equation of time table next to the 6pm stone. This dial has been set out for summer time and to allow for the difference in longitude between Blickling and Greenwich.

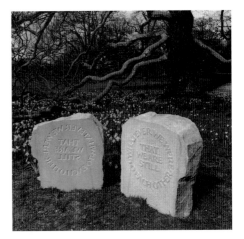

CELIA KILNER
(5) *Split Boulder 'Secret Stone'*
circa 30 x 30 inches

As well as a memorial in the graveyard or cemetery, a place for focus for formal mourning and remembrance, it is also a comfort for one's eye to be able to fall on a special reminder at home where memories of that life and that person are strongest—trees planted, flowers that bloom at significant times, words that speak to the heart—sometimes words that have no significance to anyone else.

With the 'Secret Stones' it is as though the message about the loved person has been waiting to be found. In the heart of the stone lies a reminder of a life lived, a person loved, to touch gently and more casually the heart and memories of those left behind.

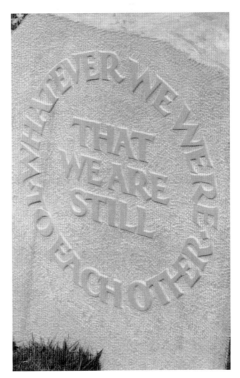

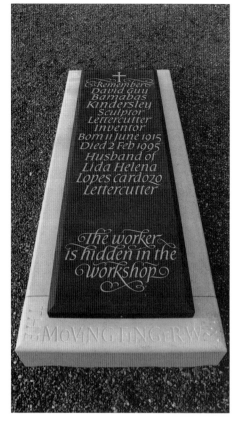

LIDA LOPES CARDOZO KINDERSLEY

(3) *Ledger Stone to David Kindersley
by his widow*
Portland Stone and Welsh Slate
78 x 30 inches

Making a memorial is about extending
the life of a loved one. Not only leaving
evidence of human existence, but of
human spirit, the positive force of a life
worthwhile. In this case it was the life of a
man I knew intimately, loved deeply and
respected totally. The tools with which I
show my love have been placed in my
hands by the very same man I am now
wishing to hold forever in stone.

The evidence of his beauty and wisdom
should show without me having to
explain—in great humility and dignity.
All life is worth our effort and attention.
This is what should last—forever old,
forever new—and this spirit should be
present in anything we make.

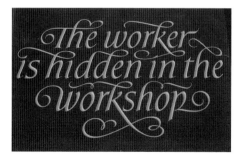

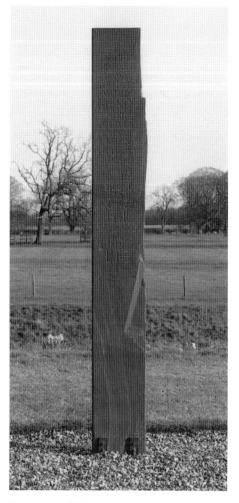

RICHARD KINDERSLEY

(19) *Standing Stone*
Welsh Slate 3.5m x 600 x 70mm

There is an ancient presence about
standing stones that still speaks to us today.
Strangely human in proportion, but giant-
like in aspect, the stones have a brooding
sentinel quality. Although dark, the
presence is not intimidating and this
makes them a powerful and evocative
memorial.

The text
hints at the
continuity
of life,
emphasised
by the use
of the first
person.
The stone
is Welsh
slate with
naturally
cleaved
surfaces.

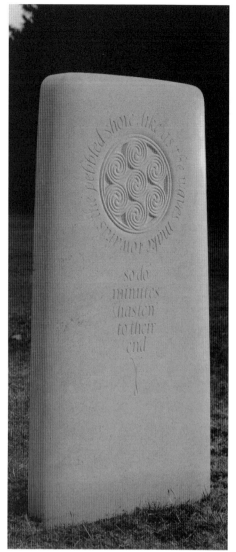

RICHARD KLOSE

(10) *Standing Stone with Spiral*
Griffeton Wood Stone 42 x 23 inches

Some time ago I was looking through a
reference book on Celtic art when I came
across a photograph of the Aberlemno
Stone (a cross slab-stone). In the centre of
the cross was the spiral that I have repro-
duced here. What I liked about it, and
inspired me to carve it, was its ancient ori-
gins, its self-contained completeness, and
its strength, and spiritual quality. In the
original carving the spirals move in an
anti-clockwise direction; however, there are
many examples of spirals turning clockwise
and I have chosen to reverse this one as I
think it harmonises with and imparts
movement to the lettering. The text, taken
from a Shakespeare sonnet, describes the
constant flow of time. I think this fits well
with the rolling and tumbling feel of the
carving and its sense of unending move-
ment.

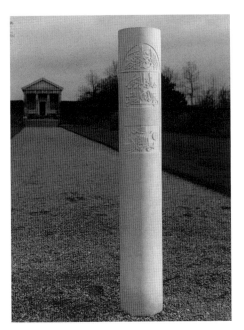

KARIM LAHHAM

(20) *An Ottoman Islamic headstone (shahid)*
Beach Basebed Portland Stone
2134 x 305mm

The Shahid, meaning 'witness', is no stranger to European epigraphy. The plains of Thrace, Macedonia, Bulgaria and countries further west are replete with examples of Ottoman epigraphy. Contrary to popular opinion, the frontiers of Christendom and Islam for more than a millennium were never hermetically sealed lines on the geopolitical and cultural level. There was no medieval 'iron curtain'. My main attempt in carving a shahid was to re-introduce a stylistic template that is entirely Islamic and equally European, and therefore capable of being developed in England.

Translation of the Arabic:
Line 1: In the name of God the Merciful and most Compassionate
Line 2: This is the tomb of the forgiven
Line 3: The Servant of God known as
Line 4: (left blank for the name)
Line 5: The year 14— (reamaining dates left blank)
Line 6: He is the Creator the Self-Subsistent

The Islamic Calendar is dated from the year in which the Prophet Muhammad moved to Medina and established the first Islamic Community (622 CE).

It is deeply hoped that this style of may be once again adopted; although obviously modified in size and in certain places substituting the name in Arabic with English.

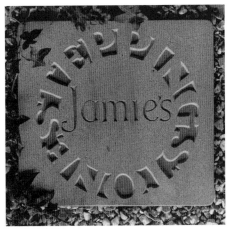

GILLIAN MADDISON

(36) *Jamie's Stepping Stone*
Yorkshire Sandstone
12 x 11 x 2 inches (minus base)

This small stone carved in Yorkshire grit stone was made as a Christmas gift. The size kept small to enable the child to relate to 'his' stone on which only he could stand and become King of the Castle, untouchable by siblings and perhaps momentarily safe from rebuke after being naughty.

The raised outer letters were designed to be touched. Also to demand some effort in their reading by the child; the painted counters assist the reading as well as enlivening the whole stone.

A stepping stone could also symbolise a child stepping from one world to the next with perhaps a suitable text or imagery combined with a name, placed in the garden or churchyard.

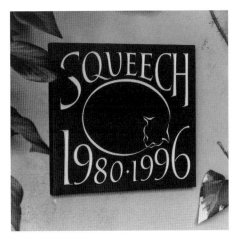

ERIC MARLAND

(33) *Squeech's Slate*
Welsh Slate 12 x 13.5 x 1 inch

Squeech's slate came about because two little girls visited me with their father when their beloved cat died after many contented years. They wanted a suitable memorial to what must have been not just a much missed pet, but also a constant feature in their lives, as he was older than the two of them put together when he died.

We agreed Welsh Slate was an appropriate material as Squeech had been black, so I looked about the workshop until I found a spare piece proportionate to a cat as I couldn't afford to order a piece specially for the price I had quoted.

Unfortunately the text didn't seem to fill the shape that I had rather arbitrarily chosen, but it occurred to me that a sleeping cat nestling amongst the letters might provide a solution. It was at this point that I realised, as with all my best ideas, it was someone else's first. My predecessor at The Carving Workshop, Jamie Sargeant, had carved the perfect sleeping cat on a headstone some years previous and there was still a photograph of it in the workshop.

I sent him my design asking permission to use his sleeping cat, which he kindly gave.

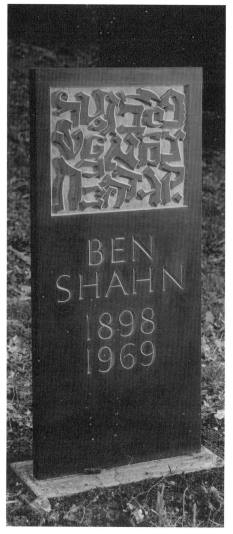

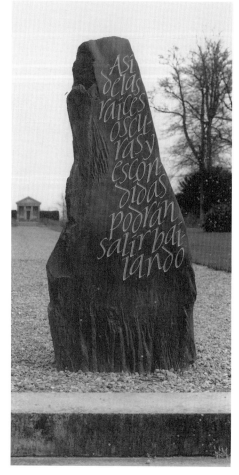

SARAH MORE

(24) *Two Memorials to a Cornishman*
Welsh Slate for formal stone and English
Oak for private marker with oil colour
35 x 20 x 2 inches and 54 x 9 x 4 inches

I have chosen to exhibit two memorials to
my father who died recently in his 98th
year. The churchyard memorial had both
to express the feelings of his family and to
stand as a more public record of his life.
This guided my choice of words for his
epitaph and the prominence I gave to the
badge of the Royal Artillery which he
served with pride through two world wars.
I used slate as it seemed to combine
dignity with restraint; Cornish granite,
an obvious choice, couldn't easily yield up
the detail and clarity demanded by the
carving.

I also wanted to carve a more personal
memorial, not to the professional soldier,
but to the man who was my father, a Cor-
nishman who dreamt of ending his days in
a simple wooden hut, watching the sun
lighting the water and the wind moving
the rough grasses. I have tried in the relief
carving to represent this, and English oak
seemed the right material for this memori-
al. It is tough and uncompromising and
rooted in the symbolic landscape of this
country. As I worked on the design, I
began to realise I wanted to set this marker
in a place that was significant to us both
and that my father knew and appreciated.
I felt it should stand in the sightline from
my wooden workshop to the distant
sparkling river.

I have tried to reconcile the private
and public aspects of commemoration
in making these two memorials. Together
they complete a picture.

JOHN NASH

(28) *Memorial Tribute to Ben Shahn*
Welsh Slate 32 x 15 x 1.5 inches

Artists, writers and musicians often have
headstones bearing appropriate objects
and quotations, but all too seldom (or at
least this is my impression) are these
representations drawn from the subject's
own work. Why shouldn't (for example)
a composer have a bar of his own music
on his tomb? A memorial to the American
artist Ben Shahn would lend itself
especially to this treatment, since Shahn
was as articulate with words as he was
skilful with paint and graphic design.
This exhibition piece shows, on one side,
Shahn's 'chop' or identifying stamp,
composed of the letters of the Hebrew
alphabet, and on the other, an observation
from one of his lectures which any artist or
craftsman would do well to take to heart:

*Craft is that discipline which frees the spirit
and style is the result.*

JOHN NEILSON

(47) *Slate Monolith*
Welsh Slate 60 x 24 x 18 inches

The text is the last verse of the Chilean
poet Pablo Neruda's 'Oda al otoño' (Ode
to Autumn), from his collection *Odas
elementales*. It translates literally as:
'And so from the dark and hidden roots,
the fragrance and green mist of Spring will
be able to dance forth'.

Autumn's difficult, serious, apparently
useless job of un-doing, becoming silent,
switching off, is both a longed for relief
and essential preparation for the rebirth
of Spring.

The text seemed appropriate for a
memorial which is, after all, a marking
of the continuity of life as well as the end
of it.

I hope the stone appears, like the
elements of Spring in the text, to be
emerging from the ground.

As there is no space for a name, it would
be best to think of this as a kind of 'memo-
rial sculpture' rather than a traditional
headstone.

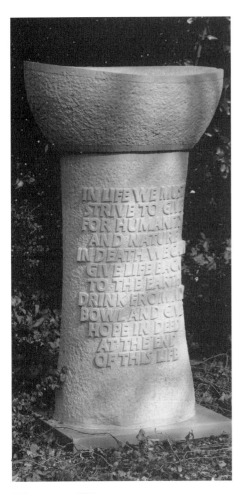

WILLIAM O'LEARY
(12) *From the Earth to the Heavens*
Beer Stone 33 x 23 inches

The idea for the memorial font came at the Christening of my son Arthur, at the local church.

The font blessing new life inside the church, the memorials in the churchyard marking past lives. This memorial font will symbolise both new and past lives. Life cycles. Birth and death.

This cyclical theme is represented in the circular forms of the bowl and its column.
In a cosmological sense the constant birth and death of stars, planets and moons. We are stardust after all. I want to show our lives as part of the 'bigger picture'.

DAVID PARSLEY
(41) *Commemorative Tablet to Owen*
Welsh Slate and York Stone 15 x 15 inches

Harriet Frazer writes: We wanted to find a way of thanking Owen Sayers, the Head Gardener at Blickling, for his help in finding and suggesting sites for the exhibits, and for the extra work there will be this season owing to *The Art of Remembering* exhibition. We also wanted the tablet to commemorate Owen's gardening genius. He has been at Blickling for 36 years and has been head gardener for the last ten years. He will be retiring in 2000.

I suggested to Owen the idea of some sort of commemorative stone. He said that it would be fine as long as it wasn't too formal and 'as long as I will still know I am alive'.

David Parsley was asked to design and carve the tablet. Hibbitt & Sons, the family firm of monumental masons David has worked for since 1981, have sponsored the exhibition by providing the Welsh Slate and giving David the time to carve the stone.

David Parsley started a 5-year apprenticeship with David Kindersley in 1950. Following his National Service, David returned to the Kindersley Workshop for a further 24 years where he worked on the majority of major commissions, including a number for the USA and other countries. Since joining Hibbitts he has worked on a wide variety of projects and is their principal designer and lettercutter.

Hibbitt & Sons are members of The National Association of Memorial Masons.

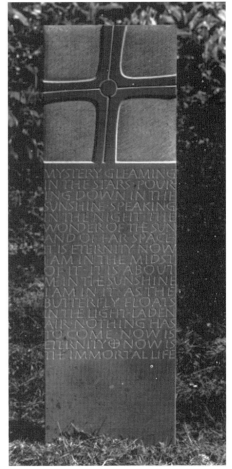

TOM PERKINS
(29) *Memorial – Mystery gleaming in the stars*
Welsh Slate 39 x 12 x 2 inches

There is a simple underlying geometry in the design of this headstone. I like to 'overlay' this underlying geometry with more freely conceived symbols and letter-forms creating a tension between the two approaches—humanised geometry would be a good way of describing this way of working. The cross symbolises the meeting of two dimensions. The horizontal can be seen as representing the temporal world and the vertical the spiritual realm. A spiritual dimension to life has largely been erased by modern secular culture—the implications of which surround us at every turn.

The words on the slate are from *The Story of My Heart* by Richard Jefferies (1848-1887) who was the son of a Wiltshire farmer. He had a remarkable power of observing nature combined with a deep poetical and philosophical insight. We should be grateful to Richard Jefferies for reminding us that there is a contemplative side to life in which potentially time stands still and 'All is and will ever be in now.'

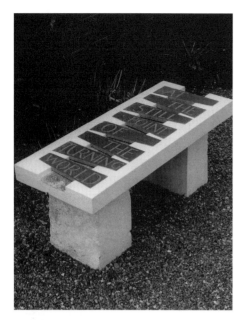

John Pitt

(51) *Seat*
Portland and Welsh Slate
1000 x 400 x 400mm

A place to sit is a place to reflect. It allows the business of the day to fall away for a moment, and for the body to become still. A place to sit is where we can choose to call up memories, and to turn our mind to recollection. The world turns, but we can steady the movement momentarily.

A seat is an appropriate piece for the exhibition, allowing visitors an opportunity to rest, the text being a focus for contemplation. Taken from T S Eliot, and crisply cut into the slate slats—which contrast with the surrounding Portland—it reads: 'At the still point of the turning world.'

I hope visitors will find silence here.

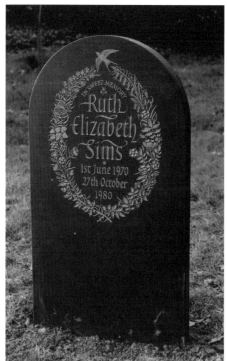

Ieuan Rees

(26) *Headstone to Ruth Sims*
Welsh Slate 915 x 500 x 65mm

On Mr and Mrs Sims' request my initial designs for Ruth's headstone were simple: they wanted plain letters with a design of wild flowers and a swift or swallow. However I was unhappy with them. Mrs Sims had often said during our discussions together, that 'Ruth was such a loving child' and on keeping hearing these words I realised that there was nothing 'loving' about the designs.

I felt that Ruth and the flowers should not be separated. I hoped that by surrounding Ruth with a garland of flowers they would represent the warmth, the love and protectiveness of her parents as they embraced her. Also I wanted the headstone to show that Ruth had not died, but rather that her spirit was alive and free to fly away to her continued life, as suggested by the swift flying out of the garland of flowers.

I was pleased that Mr and Mrs Sims were comforted by the design, and I am grateful to them for allowing me to produce a copy of Ruth's headstone for this exhibition. As I did not want to execute a lifeless copy, this headstone, although based on the original drawing, was executed freely, in order to capture the life and spirit of the original which was in Nabrasina stone. By so doing some accidental changes have naturally occurred as well as a few deliberate ones.

Michael Renton

(30) *A Headstone to MR*
Hornton Stone 30 x 20 x 4 inches

The idea of doing a memorial to myself was suggested by the example of Eric Gill who did the same as a specimen for an exhibition in the 1930s. But so that it should not be taken too seriously or tempt Providence (EG's friends were alarmed, and in fact he died only four years later) I have omitted any reference to age or dates (even of birth!). In any case, are memorials only for the dead?

Clients for memorial work are often looking for something fairly conventional, and I am happy to do a straightforward job for anyone. But here, with only myself to please, there seemed room to play a little.

 The bunch of tools on the back of the stone is meant to represent the various media in which I work.

The whole of this side aims to convey the notion—another owing much to Eric Gill and David Jones—of workmanship as offering, which has however to be taken up into something greater to be of any ultimate value. The words from Augustus Toplady's well known hymn, 'Rock of Ages' rarely fail to raise a lump in the throat if I find myself singing them in church; the wording round the edge of the stone is from the Nicene Creed.

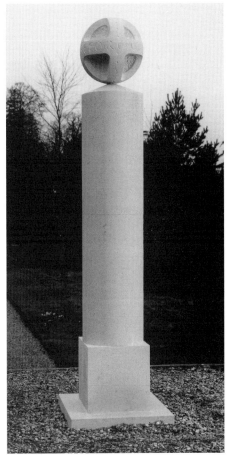

MICHAEL RUST
(11) *Memorial to Farm Cats*
English Oak 48 x 18 x 3 inches

The piece prepared for this exhibition arose out of the many years I spent in the past as an organic farmer. Cats are the unsung heroes and heroines of rodent control on many farms and their individual characters are not always acknowledged. All animals remembered here were working cats helping to run a farm that was committed to producing food without recourse to poisons.

The inscription includes a quotation from *Eesha Upanishad*, one of the sacred books of the eastern Vedantic tradition, and emphasises the unity of all Life. My personal philosophy echoes this sentiment and I aim to bring this to bear in all I do in my work.

In contrast to the straightforward thoughts expressed in the names and epitaph, the shape has an abstract and strong sculptural feel which arises from my work as a carver as well as a letterer. Although I work in stone and engraved glass as well, I felt the warm simplicity of wood was a wholly appropriate medium with which to remember these wonderful creatures.

JAMES SALISBURY
(52) *Commemorative Sundial/Bird-bath to Gillian Poole*
Hornton Blue Limestone 31 x 12 inches

Gillian had a sharp and wicked sense of humour and a wonderful ability to engage with awkward teenagers. She was the confidante for me and most of my friends.

Gillian was and is our greatest family friend. Her daughters are as cousins to me. She died from arthritis and complications due to its treatment 10 years ago. I have from time to time thought of her, and the interest she took in my early artistic leanings, and thought that I would like to make something for her daughters as a marker for all our memories (other than her gravestone). In deciding to make a garden memorial, and talking to her family, a long list of whims, likes, passions and qualities was made from which some have been chosen to depict on the carving. The idea of a sundial with dished top (for a birdbath) arose and the drawing developed to the finished item. I know the idea of birds feeding and suchlike in the top of a sundial would tickle Gill and serve to illustrate her unshakeable humour in pain.

JAMIE SARGEANT
(21) *Design for a Garden of Remembrance*
Portland Stone 2280 x 360mm

A Garden of Remembrance memorial provides a place for names to be inscribed as the need arises. A point of rest in the churchyard reflecting dignity and continuity; regularly added to and yet remaining constant.

This is one possible solution to the demands imposed on small parishes to meet a need within the constraints of a small budget. The column can carry at least 45-50 names—each being added below the last at the point where one ends and the next begins, thus creating an unpredictable texture.

The design is based on simple geometric volumes—the cube, cylinder, sphere and cone—these being elemental forms symbolic of earth and spirit.

The Portland column and cruciform ball finial were made and fixed by A & J Woods (Masonry) Ltd. of Norwich.

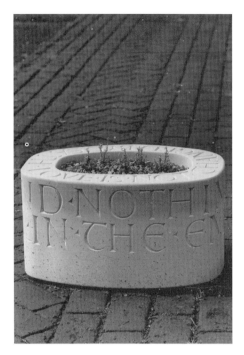

JOHN SKELTON
(14) *Planter*
Portland Stone 24 x 16 x 12 inches

The idea of a planter came about through coming across this quotation from Edith Sitwell: 'Love is not changed by death and nothing is lost and all in the end is harvest'. To me this declares the existence of the present, the promise of the future and expresses the hope of eternity.

The erection of a memorial may be an act of love, an act of duty or a desire to mark an event publicly. This memorial could go in a private garden or as a centre piece for a Garden of Remembrance or be a tribute to the gardening world at large.

NICHOLAS SLOAN
(9) *Cast-iron 'Stone' to John Harrison*
36 x 18 inches

Four thought: first is my feeling that cast-iron, which has in fact been used for centuries in this country for memorials, is now a much undervalued material. It is adaptable, durable, relatively cheap, and it can weather beautifully or be easily painted. It also appeals to me in being somehow honest and unassuming.

Secondly, I like the sturdy egyptian or clarendon letters that have traditionally been used for English cast-iron street names. I begin to find the restrained good taste of predictable roman and italic on gravestones a little stifling, and it is nice to make a letter with a bit of punch from time to time.

Thirdly it is also a treat to revel in colour. There may be contexts in which very colourful memorials would look out of place, and certainly I should not welcome it if every gravestone shouted like a high street shop front, but I do think that we have become too timid about exploiting the rich potential of colour.

Finally, it is good and fitting to be able to pay homage to John Harrison, the stubborn genius whose infinite patience and ingenuity gave birth to the first reliable marine chronometer.

CHARLES SMITH
(44) *Passing through Nature*
York Stone 72 x 30 x 3 inches

The carving of letters in stone is absorbing but much more so when the words have great meaning for the carver. Such quotations, which mean something to me, I put by until I know what to do with them.

Visiting the Hancock Museum in Newcastle-upon-Tyne a couple of years ago I was stunned by the sight of one exhibit in particular, Magnificent Frigate Bird.
I knew there and then that I should use a design based on this bird to illustrate the words from Hamlet, 'Passing through nature to eternity'. Eighteen months later when I sat down to draw something for this exhibition the design worked itself out in minutes.

As I write I have the complete carving to make which will involve many hours of hard work—but work with utter contentment.

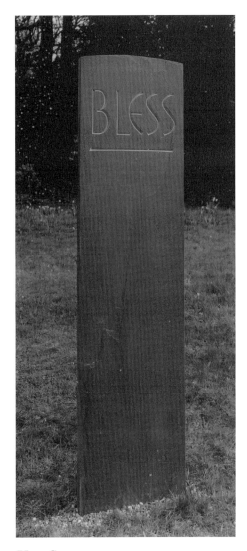

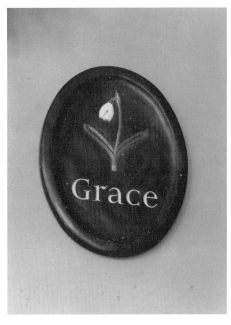

KEN THOMPSON
(34) *Grace*
Kilkenny Limestone 20 x 15 x 1.5 inches

The piece is entitled GRACE and represents a memorial to all children who die before, during or shortly after birth. The *snowdrop*, so vulnerable, is a metaphor for their short and innocent life and the brief delight which they bring to their parents. GRACE, is a word that perfectly describes the snowdrop and might also suggest the concept of *free gift*. The oval seems the right form to carry the image.

CAROLINE WEBB AND
RON COSTLEY
(43) *A Memorial Bench*
17 x 10.5 x 44.5 x inches

A bench, or more usually a seat, is a popular and much appreciated form of memorial. But all too often the identifying inscriptions are either briskly informative or uninspiring: 'Given by friends of T.W.' and 'In memory of G.A. who loved this view' are typical.

This proposal demonstrates that the idiom, though simple, can carry wide cultural references and inspire deeper reflection.

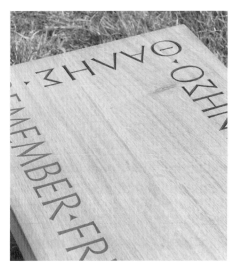

The text, deliberately non-specific for this exhibition is a saying of Thales, one of the Seven Sages of Greece:
ΦΙΛΩΝ ΠΑΡΟΝΤΩΝ ΚΑΙ ΑΠΟΝΤΩΝ ΜΕΜΝΗΣΟ / REMEMBER FRIENDS BOTH PRESENT AND ABSENT.

UNA SULLIVAN
(48) *Standing Stone*
Riven Welsh Slate 58 x 15 x 2 inches

My piece of work is a standing stone. A slab of riven slate 58 inches tall and 15 inches wide. This is the kind of shape I like to work on at the moment. It allows a lot of space to be left around words, isolating them. I had no personal memorial to make so it had to be something universal. I thought the word BLESS could stand on its own, outside of any particular context, but that it needed emphasising visually. I considered a gold line underneath to be appropriate, mirroring the feeling of the word BLESS as being a happy word.

Although the gold line worked on paper and as a mental image, it had a surprisingly detrimental effect when actually used; detracting from the word so much that it virtually disappeared, and disassociating the space above from the space below. The gold had to be cut away and the line left clean for the piece to work.

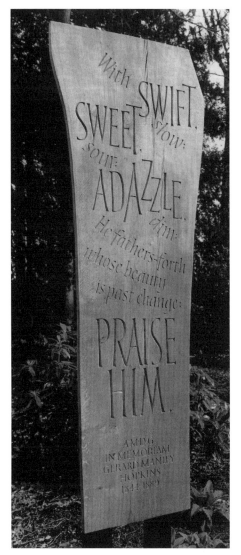

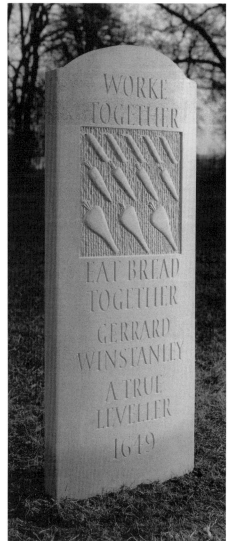

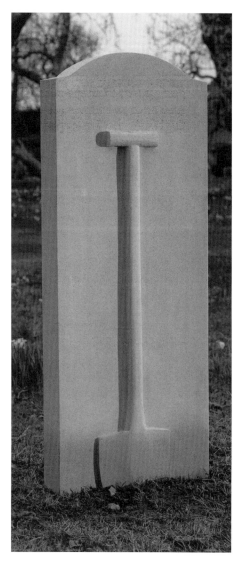

MARTIN WENHAM

(15) *Memorial to Gerard Manley Hopkins*

English Oak 78 x 28 x 1

This memorial is to the Jesuit poet Gerard Manley Hopkins. It attempts to communicate in visual form some of the properties of his poetry; in particular the way in which meaning and sound are juxtaposed and contrasted. The text is the last three lines of his poem *Pied Beauty*: a piece so often anthologised that it is easy to forget how complex and original it is. It is carved on a butt plank of oak with the text dominating. The memorial inscription itself is small and modest, headed by the letters A M D G (Ad Maiorem Dei Gloriam (to the greater glory of God) the motto of the Jesuits)—a dedication which fits my work (I hope) as well as it did that of Hopkins.

Butt plank of oak (from the base of the tree) from Staunton Harold, Leicestershire.

ANDREW WHITTLE

(7) *To The Diggers*

Portland Stone 45 x 15.5 x 4 inches

The Diggers (True Levellers) were a group who believed that poverty could be relieved by allowing the poor access to Common Land.

Led by Gerrard Winstanly they settled on St. George's Hill, Surrey in April 1649, building shelters and working the land collectively. The first crops planted were Parsnips, Carrots and Beans.

They refused to defend themselves and were beaten and harassed by local landowners who wished to enclose the Common Land for their own profit. By the following April the settlement was destroyed. At present nothing marks the site of their struggle. I feel that their attitude of non-violent direct action (they were precursors to the Quakers) deserves to be remembered. The Common Land at St George's Hill is now a golf course.

Then and Now

CHARLES SMITH

In the North East of England, for at least two decades after the second world war, there was a burgeoning of fine lettering in the monumental trade. The letterform upon which it was founded was that of the Trajan alphabet. It was being taught at Kings College, Newastle (later Newcastle University), by L C Evetts and it was adopted whole-heartedly by a considerable number of monumental firms and lettercutters at that time. Individual firms collectively pursued this alphabet as the ideal in a miscellany of stones—not only those of a kind which are receptive to lettering, such as an accommodating limestone or a soft slate, but in a whole variety of materials such as local, very hard, abrasive sandstones, marbles and a considerable number of granites from Britain and abroad. Some from this latter category were very tough indeed. In a sense nothing was too difficult material-wise, such was the enthusiasm (and not a little rivalry) for this beautiful alphabet. Consequently cemeteries and churchyards dotted around Newcastle and the North East contain many fine memorials made by these trade lettercutters. Work like this is, of course, 'unknown'. It stands silent in the burial grounds, as it is supposed to. But it is there for those who are willing to seek it out.

My apprenticeship commenced with a Newcastle-upon-Tyne monumental firm in the late1950s. I came into the Trade when the above activity was perhaps at its height, which of course I just took for granted. Evetts' teaching had ceased but my training was received from those who had studied with him, and from his book, *Roman Lettering* which was pre-eminent in the workshop.

We were schooled in what was then a general practice of working. No drawings were supplied to the client. The inscription was drawn directly onto the stone, great care being taken with the spacing. After this it was read off, letter by letter, and we proceeded to carve. What we had to aim for eventually was to be able to carve an inscription with as little 'marking on' as possible. The emphasis was on finding the forms with the chisel, rather than relying on the drawings of finished letters. This latter method of course could produce good work, but it was felt that if you found your forms with the chisel, this gave you more freedom and produced work with more life; and it was ultimately quicker. Speed was very important. In addition to inscriptions in pure Trajan (all capital letters), the Trajan capitals were conjoined with Roman miniscules, Roman italics, sans serif and other letterforms. From the start you had to use your initiative and, of course, take responsibility for your mistakes.

Some years after my apprenticeship, when I was working as a free-lance lettercutter to the trade, I came to feel that the inscriptions I was carving were in a sense 'working themselves out'. By following classical letterforms and spacing I was merely copying what had long gone before. I felt that I was not actually doing anything. Nothing was coming out of my own head. This meant that I had to start evolving something of a more personal nature, as of course we all have to. We cannot simply go on repeating the past.

That was then. Now it is even more complicated. We live in an age where everything is instant—an age of incredibly sophisticated computer technology. This engenders a climate which produces questions such as 'Haven't you got a machine to do that?', or 'How long did it take you to do that—a couple of days with an angle grinder?', or 'If I'm to commission a piece of lettering, how will people know it was done by hand?'

Thus the work of the lettercutter today has to justify its existence not only in the visual manner, but also in the techinical process by which it is produced. That is the challenge. It is a long way from the past, even the recent past. ◆

Training for Lettercutting

RICHARD KINDERSLEY

The task of designing a gravestone brings together a number of disciplines which, only if properly understood, enable the practitioner to make a successful memorial. These disciplines divide into the following distinct areas: knowledge of stone and its weathering characteristics, knowledge and understanding of letterforms, and, last but not least, a craft training to cut letters in stone that are permanent and beautiful.

A moment's thought will make one realise how inextricably these three strands—knowledge of stone, drawing of letters, and lettercutting—are bound together, each informing the other as to what is appropriate and right. So where does one look for training today? No longer to the monumental mason who has long since traded craft pride for the pursuit of commerce in a headlong rush toward computerisation and the mechanical reproduction of letters into stone.

While a grounding in financial housekeeping is, of course, important, it is the love of making for its own sake that sets the craftsperson apart from the pursuit of commerce. The true notion of 'work for oneself' has a deeper significance within the words. It means that the final arbiter of one's work must always be oneself—never clients, who inevitably flatter, nor the financial rewards' for they bring only temporary gain, but the ultimate reward of knowing you have given your best to getting the work right. This places great responsibility on the craftsperson; but it is this very responsibility in making, beholden to no other, that encourages gifted people to devote their lives to making beautiful objects. The combination of self-criticism and self-motivation should be welcomed and exploited to its full potential.

To reiterate the question—where is this special training to be found? The answer is a strangely modern one, full of the contradictions of our age. Gone are the days of indentured craft apprenticeships, steeped in working-class pride in a craft with its apparently unchanging body of knowledge handed down from generation to generation. The new generation of craftspeople is predominantly middle-class and without support from the formal institutions of manufacturing and training. The contemporary world they live in is awash with information on a multitude of things that are accessible as never before, through books, video, the internet, and a plethora of vocational courses both part- and full-time. Those seeking out skills for making memorials now have to search for knowledge in a more personally-driven and diverse way.

Aspiring lettercarvers should begin by looking at some of the many excellent books on lettering and carving. From examples in these books, start drawing—and keep on drawing. Drawing practice for lettercarvers is the equivalent of scales practice for musicians and its importance cannot be over-emphasised. They should also search out and visit some of the many craftspeople scattered around the country, carving fine memorials. There are more now than ever before, providing a rich resource for study. Inspiration can also be found by looking at the best examples of memorials to be found in cathedrals, churches and burial grounds. They could also attend one of the many part-time calligraphy classes, or even join one of the full-time lettering and calligraphy courses. Another, or complementary route is to attend one of the masonry colleges for a useful grounding in the working of stone. None of these resources in itself produces the necessary skills but, together, they build a mosaic of knowledge that will allow a student to approach one of the lettercarvers who take on assistants. The knowledge that has been gathered can then be honed and focused. In short, there is no established method of learning how to carve headstones, but if one is inspired by beautiful lettercutting one will be drawn to discover a way in for oneself, following intuition and the touchstones discussed.

It is salutary to reflect that the two most influential people on 20th century craft lettering, Edward Johnson and Eric Gill, were both, in the non-pejorative meaning of the word, amateurs. They became driven by a powerful desire to know the high ground of their craft. And they undertook this by diligent research, study and, most importantly, the physical application of hand and eye. ◆

Ripe for Reform

NICHOLAS SLOAN

Perhaps the best that can be said of many of the current sets of churchyard regulations is that they are often applied on the parish level with more sensitivity than they are drafted*. When I am designing a stone for someone—trying to reflect the character of the person commemorated and the needs and wishes of the client—compliance with regulations is not usually a primary consideration. Seldom would I want to exceed the maximum permitted size, but often there will be other aspects of a design (a carved image/symbol, or a non-standard form of fixing for instance) that would technically require the incumbent to refer the design to the diocese. In my experience this often does not happen, because most incumbents will look at the design as a whole and say 'Yes, I should welcome that in my churchyard'—or not, as the case may be.

Occasionally however, one comes across a vicar who says 'Yes, I love the design, but unfortunately it is half an inch too narrow'. In the last case to affect me personally, I had at the request of the client, included a simple carving of a fishing boat setting out to sea. The vicar and the diocese were delighted—just the sort of design they wanted to encourage—but because the Chancellor's Regulations permitted the incumbent to approve only 'simple decoration', the design had to go to faculty, entailing considerable extra expense and delay to my client, as well as the posting of a notice on the church notice board which she found particularly upsetting. Surely if the Church wants to encourage good and original design, it should not in effect penalize it.

This story had at least a relatively happy ending, in that the stone was ultimately approved. There are plenty of other cases where carefully considered designs are refused on apparently arbitrary or misguided grounds. Commissioning a memorial is not easy at the best of times. The quickest way is probably to go to your local firm of monumental masons and order a standard design from a catalogue. This will be acceptable to the Church provided that the wording is fairly standard too, but perhaps the person in whose memory you are setting up the stone was not standard; maybe you want to put a lot of thought into it, and to com-

mission something that reflects the uniqueness of a person you loved. You discuss this with the monumental mason or with an independent lettercutter, and together you come up with a design that is just right. The process is rarely easy, but it can be very therapeutic and rewarding. Not so the experience of having the design refused by the Church because it does not conform to regulations.

I am not denying that churchyards are very special places, and that there is a case for some degree of control over what goes into them. I do however feel that the procedures for dealing with applications could be much improved, and that the Church needs to be great deal clearer—and more open—about the principles according to which designs are evaluated. Part of the problem is that at least three disparate but overlapping criteria are embodied in the regulations. There is the practical element: memorials must be structurally sound and durable, and should not impede lawn mowers. Then there is the aesthetic element: memorials must not be ugly (though in practice any attempt to define this generally degenerates into a requirement not to be unusual). The Church cannot really claim any expertise in these first two areas, and although their attempts to maintain structural and aesthetic standards are doubtless well meant, they are often ill-informed and ineffectual. The one area in which the Church *can* claim authority is in the third criterion applied to memorials, namely their fittingness in ideological or theological terms. Unfortunately, this is where it is at its most muddled, opaque and inconsistent.

If we look back to the days when religion and art were in tune with one another—which we can easily do by visiting an old church—we find a rich loam of memorial and decorative carving in which the full diversity of life (not even excluding sex) is embraced and celebrated as part of the whole Christian picture. By contrast, we read in the current regulations for the Diocese of Chelmsford: 'The headstone is to have no decorative motif other than vertical lines or a small cross or small flower if so desired. Any other motif, such as one relating to the occupation of the

deceased, requires the authority of a faculty'. How can the vision of the Church have contracted to this extent?

The position with regard to permissible wording can be at least as repressive as that relating to images and symbols, as illustrated by the family from the Diocese of Blackburn who were refused permission to put 'Dad and Grandad' on a stone. How little respect is accorded to honesty and affection by such pharisaical rulings.

The Council for the Care of Churches has given some excellent advice about gravestones in *The Churchyards Handbook*, and this is followed by some dioceses who have far more liberal regulations than those cited above, but this inconsistency is part of the problem. Seldom is any reasoned explanation given for a Church ruling on matters which apparently relate to theological etiquette, and such rulings can vary markedly from place to place. It is clearly wrong that a carving of a dog, or the word 'Dad', should be judged offensive in one place and not in another. Surely standards of religious propriety should be constant. It is unjust not only that rulings should differ between dioceses, but also that each petitioner has to jump through the same hoops at their own expense because there are no authoritative principles as to what may and may not be allowed, and why.

The real sadness is that those concerned in these disputes are precisely those who have the greatest common interest in preserving the sanctity and beauty of churchyards. While the regulations do very little to filter out the mechanical drabness of design that is the real threat to this, they often set the more concerned masons and their clients in opposition to the clergy. So that instead of the masons helping the Church to solve the problem of increasingly ugly churchyards, and the Church offering solace to the bereaved at times of acute stress, we often find all parties embroiled in pointless arguments about details of design and procedure. Surely it is time to recognise that a problem exists and to see what can be done about it.

I should like to end with some suggestions:

1) There should be a high level ruling by the Church as to principles on which images may or may not be permitted in churchyards. Some dioceses insist that only explicitly Christian symbols will be allowed, whereas others welcome anything that is not actually blasphemous. Obviously the category into which any given carving falls will remain open to a degree of interpretation, but the *principle* should be clear. Likewise that relating to permitted inscriptions.

2) These principles should be embodied in a nationwide set of guidelines, giving as much weight to that which is to be positively encouraged as to that which is not allowed. A few things which are generally agreed to be undesirable (such as polished granite, chippings and plastic) may be made the subject of compulsory referral to the diocese, and maximum sizes (expressed in area, not height and width) may be treated similarly, but generally the emphasis will be on presenting the incumbent with a code of practice on which to base a sound judgement. This document should be produced in consultation with those who deal with all sides of the present procedure, including parish priests and lettercutters. The experience of *Memorials by Artists* could be an invaluable contribution.

3) The incumbent will have the authority to approve anything not specifically proscribed in the new guidelines. He or she will be encouraged to discuss any dubious proposal with someone qualified to advise on religious, artistic or structural matters. This would be a much more streamlined process than going to faculty.

4) If the incumbent opposes a design, and is supported by his diocesan advisers, or if a design is opposed by other parishioners, the applicant will then be entitled to petition for a faculty. If this is refused, clear reasons will be given, with reference to agreed principles. Thus it will not be possible to refuse permission on ideological grounds in one diocese, for a memorial that would have been allowed in another.

I realise that these suggestions may be inconsistent with current Church law and the independence of the dioceses. They are only intended as a starting point for discussion, but it must surely be agreed that changes have to take place in order to alleviate the real distress and confusion that accompanies the present system, and to enable all to work together to make churchyards more beautiful. ◆

*A set of regulations for churchyard memorials is drawn up by the chancellor in each diocese. If a proposal falls within the regulations, the parish incumbent (the vicar or rector) is permitted to approve it without reference to the chancellor. If a design falls outside the regulations, it is not necessarily disallowed, but a petition for faculty (ecclesiastical planning permission) must be submitted to the diocese. This costs upwards of £100.

The Gentle Art of Regulation

CHRISTOPHER CLARK

Churchyard rules and regulations have had a bad press in recent years. Their very existence can lead to passionate argument. Why have them? Who administers them? If it be some stuffy, pin-striped lawyer, advised by some equally stuffy and venerable archdeacon, what right has he or she to dictate to others how their loved ones should be remembered? Ought we not to let people just do their own thing and commemorate Grandad as they think fit? Why allow pettifogging regulations to get in the way?

Grief can be such an intense emotion. Sooner or later we all have personal experience of it. The collective intensity of the experience following the death of Princess Diana is still very fresh in our minds. Gravestones are personal memorials for people for whom we grieve. As mourners, we

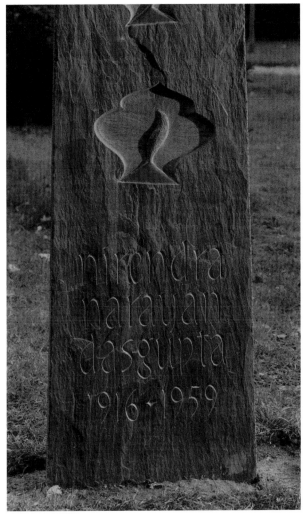

JOHN DAS GUPTA

may feel strongly about the design of a particular gravestone and the wording on it. Moreover, we live in an age when people expect to be allowed to grieve in their own way. This leads to an expectation of being able to commemorate their nearest and dearest as they see fit: 'If a young man who was keen on motor cycles was killed in a road accident, why should he not have a motor cycle carved on his headstone?'

To many, what is appropriate in a churchyard is a matter of taste. Your taste is different from my taste. Why should one person, however sensible and well-qualified, decide what is good taste? In our egalitarian age, as we approach 'the people's millennium', isn't that just another form of artistic snobbery? Why should a Diocesan Chancellor or an Advisory Committee be permitted to dictate matters of taste to an emotionally upset and vulnerable group of people like a grieving family?

These are questions which should be faced by any Chancellor or other person responsible for enforcing churchyard rules and regulations. Speaking for myself, I do not, in fact, regard it as part of my professional function to dictate matters of taste. It is, however, part of my function to supervise what is permitted within churchyards. So, how do I approach the task? How do I reconcile the absence of a desire to dictate on matters of taste with the need to supervise?

I work on the principle that I want to encourage harmony: harmony between one gravestone and another; harmony between gravestones and the churchyard as a whole; harmony between the churchyard and the church. Harmony does not equate with uniformity. Churchyards are not war cemeteries. The last thing I am seeking is exactly the same size of stone, or shape, or colour, or design, or lettering. There is much room for individuality. In particular, I welcome and encourage memorials of artistic design and with artistic lettering.

Nevertheless, in seeking harmony, I have to apply a test. I call it the 'sore thumb' test. If a proposal stands out like a sore thumb, it should not be allowed. Equally, if I go to a churchyard and see a

memorial which seems to me to stand out like a sore thumb, then the faculty process has gone wrong. Let me give some examples.

Polished stone is becoming more and more popular. A series of polished black granite or white marble headstones in a local authority cemetery may be acceptable; but put a polished marble or granite headstone alongside the wall of a medieval church and it would stand out dread-fully. There would be no harmony between the headstone and the church.

In the days when the faculty system was applied less comprehensively, kerbed surrounds appeared in many churchyards. People liked them for the territorial feeling created, and thought they made the grave look 'a fine and private place'. Nowadays, however, kerbed surrounds are discouraged. They do not fit in well with other graves. On the other hand, in a churchyard where kerbed surrounds are prolific, it would be absurd to say that another kerbed surround close by would not harmonise. It would be within the 'sore thumb' test.

Sometimes the dividing line between what is harmonious and what is a matter of taste is extremely fine. Do I discourage 'open book' style memorials because they are out of keeping with other headstones, or because I do not care for them very much? Perhaps it is a combination of the two, but I try to keep personal preference under wraps if possible.

Nevertheless, it is not the 'open book' style of memorial that is creating the present headache with which all chancellors are having to cope. This arises from the two-fold trend of (a) asking stone masons to put a secular design or motif on the headstone and (b) wanting a glazed photo-graph or picture of the deceased on the memorial. The latter are particularly common in continental cemeteries. Why should they not be permitted in churchyards here? The time may come when they will be, but at the moment I think they would stand out inappropriately in the average churchyard. As for designs or motifs like, say, the motorcycle referred to earlier, one has to be particularly careful and sensitive. Some think such designs or motifs out of place in a Christian churchyard. On the other hand, if the bereaved are desperately keen, and the design can incor-porate the request simply and unobtrusively, they

may well be an argument for saying it should be permitted. This is where sensitive and tactful dis-cussion between the bereaved, the incumbent, and the churchwardens may lead to an agreed solution, which, if necessary, can be put before the Chancellor for approval.

Some years ago the Anglican Church received bad publicity when the 'Grandad' dispute occurred in a Lancashire churchyard. The impression created was that the Church is narrow-minded and out of touch with the way ordinary people think and speak of each other. In that dispute it may be that there was little personal contact between the incument and the bereaved. I strongly believe that an incumbent must listen to the views of mourners and discuss sympathetically with them what would be the appropriate wording on a memorial. Nor should he or she leave it until the last moment when the memorial mason is about to inscribe or, worse still, until after inscription.

It is to be borne in mind that inscriptions will gradually weather away after a century or more. Moreover, many would say that inscriptions should reflect the fashion of the age. Victorian and surviving earlier inscriptions reflect periods when the English language was generally used in a grander, more expansive way. A tendency towards less formal inscriptions is the fashion of the present time. If the family want it, is 'Bill' as opposed to 'William' really objectionable? I myself draw the line at nicknames on their own, quite simply because, if members of a family wish a person to be buried in a Christian churchyard, they should expect his/her memorial to have his/her Christian name on it. If a Christian name, however, is followed by a nickname, per-haps in small lettering or in brackets, is that truly objectionable? For family and friends, the nick-name may be an important part of the memorial; and, for on-lookers, it adds to the interest without, in my view, standing out offensively.

Many of our churchyards are truly beautiful places. They are not, however, to be preserved in aspic. New graves will be needed, new memorials will be commissioned. In response, carvers and masons can use their imagination and skill to create fine and enduring works of art. Provided they seek to create memorials that harmonise with their surroundings, they should have no need to fear the rules and regulations. ◆

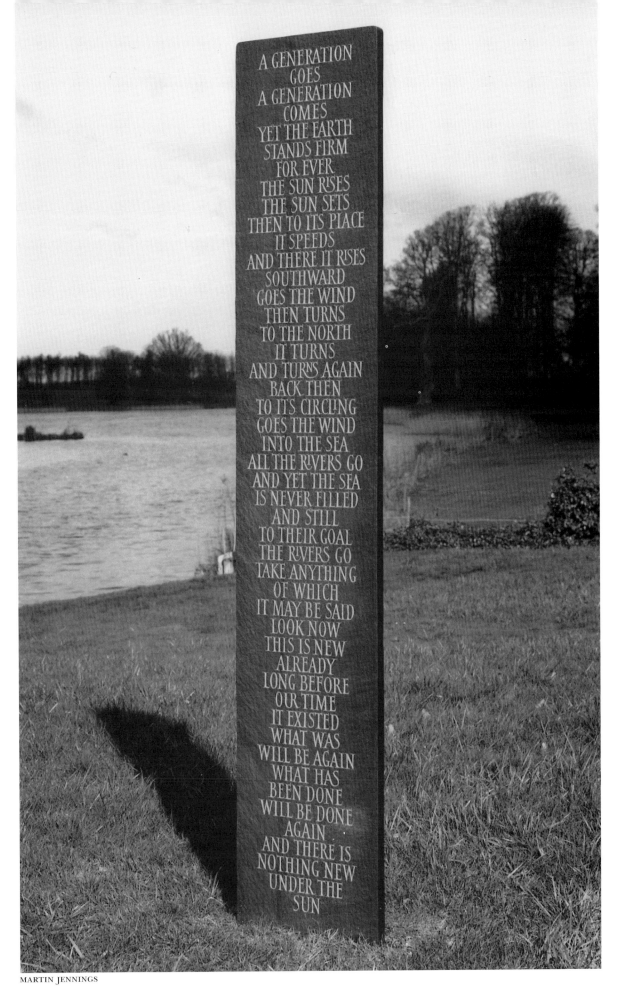

MARTIN JENNINGS

Traces of Immortality

DAVID ROBINSON

When I first walked through the gates of the Paris cemetery, Pere Lachaise, I had no idea what to expect. I had never given much thought to cemeteries and had gone there out of simple sight-seeing curiosity. Yet what I discovered on that first visit prompted me to return again and again, and inspired me to visit hundreds of cemeteries throughout France, England, Czechoslovakia, Spain and Portugal, taking 10,000 photographs and producing two books.

From the beginning, what drew me to these cemeteries was the art and the expression of emotion in the commemorations. I was never interested in the 'official' or state monuments where a nation's kings and heroes are buried. Instead I concentrated on the large cemeteries because they were so diverse and so much more alive. There one can observe not the kings, but the common citizen, and experience the individual and collective quest for immortality. I could only cope with the vastness of the cemeteries by concentrating on the intimate details. Many tombs, and not just the elaborate ones, were deeply moving in the sentiments they expressed. The personal expressions of love and grief took many forms. I could only admire their originality and marvel at the creativity employed in the service of honouring the dead. All the specific details of the tombs—the inscriptions, the souvenirs and photographs, the flowers and wreaths placed on graves, the wrought iron, stained glass and architectural details of the tombs themselves, as well as all the sculptures— are what I call 'traces of immortality'. This formed the raw material for my photographs.

Gradually, I began to form tentative conclusions about what I was photographing. I came to believe that cemeteries look forward—to life

everafter—as much as they look backward to the past. They celebrate not only lives lived, but lives yet to be lived—in eternity. Their true focus is not mortality (history) but immortality (hope).

Despite all the articulated grief, cemeteries strike me as places of optimism, not morbidity. The expressiveness of the memorials made me realize that cemeteries are for the living, not the dead—it is we who need them. Although predicated on paying respects to the deceased, in reality they are vehicles that allow the living to grieve and remember. Thus they play a crucial psychological role for individuals and the community.

I had always assumed all cemeteries to be ancient, but I discovered that they are, in fact, relatively recent creations, owing their origin to reforms in the early nineteenth century. Père Lachaise (1804) was the first of these 'modern' cemeteries, serving as both model and inspiration for scores of others all over Europe and parts of the United States. Throughout the nineteenth century, new cemeteries were created 'extra muros'—outside the walls of major cities. The first in Britain were opened in the 1820s on the edges of cities such as Manchester, Liverpool, Norwich and Glasgow.

The new cemeteries represented a profound shift in the way people were buried and the way their memories were honoured. In the late eighteenth century, churchyards and burial grounds began to run out of space. The English population had grown rapidly with the Industrial Revolution. By the early nineteenth century, twenty-three cities had populations over 100,000, mortality rates were enormous, and churchyards and burial grounds overflowing. Descriptions of burial conditions make for gruesome reading. Today it is hard to imagine how the foul conditions of the old burial grounds and the indignities suffered at the hands of drunken porters could have been tolerated for so long. It was only when people, prompted by the so-called 'miasmatist lobby', began to connect such conditions with prevailing disease and epidemics, that there were calls for reform, and proposals for a new type of cemetery.

Broader changes were also taking place in English society during an era of reform that the historian, James Steven Curl calls 'a general movement towards the civilizing of urban man. He notes that 'compassionate feelings towards the

weak and the poor were also shown towards the bereaved and the dead'. People began to protest against the lack of respect for the dead shown by the whole system of indifferent and callous burial.

Iit was the garden cemetery movement that helped shape cemetery reforms, creating places which provided for both the dead and the living. Washington Irving wrote, 'The grave should be surrounded by every thing that might inspire tenderness and veneration for the dead, or that might win the living to virtue. It is the place, not of disgust and dismay, but of sorrow and meditation.' The new cemeteries were conceived as vehicles for moral and spiritual uplift, where the deceased could find peace in the bosom of nature and visitors could stroll, meditate and draw inspiration. As Philippe Aries describes it, 'The new cemetery was located...in a picturesque spot. It was designed as a park, a public garden, offering a welcome to the stroller.... The concept of death that emerged was altogether new, less linked to religion and more associated with both public and private life. The bereaved adopted a habit they had never had before—that of regularly visiting the tombs of those that death had wrested from them. Nature's hospitality would assuage their grief.'

Cemetery reform contained seeds of change that went far beyond matters of public health and respect for the dead. There had been problems with the Church restricting certain burials in the consecrated ground it controlled; indeed, in England, the first voices for cemetery reform had been those of Dissenters, seeking to escape the restrictions of church burial. The new cemeteries, under the supervision of the municipality, not the Church, were open to all faiths, as well as non-believers, each with its own burial area. As cemeteries were situated outside towns (further away from churches), the burial in the cemetery became separated from the funeral service in the church, and the Church's control over burial rituals was weakened. Burial became more secular, allowing people freedom to choose new forms of commemoration. There was a growing need to give expression to emotions which the traditional rituals could not adequately encompass.

Cemetery reform required individual burial—no more mass graves. Although this was nominally for health reasons, it further encouraged individual commemoration and personalisation of the

grave. In the old burial grounds it was impossible to know where a particular body lay. New laws provided for long term leases of distinct sites where people could establish graves for themselves, their relatives and heirs. Permanent plots made elaborate monuments and mausoleums a realistic proposition. For those who could not afford grants in perpetuity, renewable short-term leases were created, so that some form of marker could be erected.

Commemoration was no longer restricted by class. In the churches, only the aristocracy had been allowed any sort of monument; in the new cemeteries, it was the middle class, prospering in an expanding economy, who built monuments most enthusiastically. Monuments became a means to validate success, establish the family reputation and, in the bargain, gain access to eternal life.

These factors combined to shape a public display of familial commemoration far removed from the passive acceptance of anonymous pits only a few years earlier. Philippe Aries speaks of a profound psychological shift. In what he terms 'the sense of the other', the emotions prompted by death were no longer centered on oneself, nor on the community, but on the family. Although, in the tradition of Christian humility, one might specify a plain and simple grave for oneself, a loved one deserved better. Not to provide a monument consistent with and expressive of one's love, befitting the deceased's social standing, good deeds and personal qualities, would be an insult to the good name of the family.

Such monuments were, of course, geared to the future as well as the past—to gaining recognition in heaven as well as society. The stronger the belief in immortality, the more death was depicted as positive. The horrific images of death that typified previous centuries were replaced by images of peaceful repose—the 'Beautiful Death'. Life after death was transformed into a positive image to suit one's love for 'the other'— the loved one.

The emerging picture of immortality involved several positive symbols. The first was nature (the original conception of the modern cemetery being that of a lush garden); another was the sleeping figure. Thus death was literally portrayed as peaceful repose in the natural setting. The concept of death as sleep was not new, but in the concept of the 'Beautiful Death', it became not only peaceful, but restorative. The emphasis on family affection led to faith in the certainty that all its members and loved ones would be reunited in the afterlife. Sleep was temporary, to be awakened by reunion. It follows that if death was not final, it could not be ugly. The beauty of the body was replaced by the beauty of the soul which could not decay.

Nevertheless, the separation from the loved one, however temporary, was deeply mourned. The exquisite sadness depicted on so many tombs was the extreme grief of impermanent loss, like a wrenching goodbye at a train station. Reunion with the departed—who was now waiting in tranquility—depended upon belief in immortality. This belief was kept alive by active remembering—commemoration. Invoking the memory of the departed also helped conquer the fear of death: as long as memory was kept alive, death

maintained at the cemetery office) and, under the ground, the stamped-out metal casket shells resembling nothing so much as those bronzed and silvered souvenirs for sale at airport gift shops.'

The definitive history of twentieth century funeral rituals has yet to be written; but over the years several commentators have noted trends that are familiar to us all, whether in Europe or the USA. Dying has moved from the home to the hospital and so has become separated from life. Funerals, likewise, have moved to the specialized environment of the funeral parlour. Rituals of mourning have become less expressive. There is an attempt to sanitize death and to bottle up the emotions. 'A great silence has settled on the subject of death in the twentieth century,' notes Philippe Aries. And Elisabeth Kubler-Ross, in her landmark book, *On Death and Dying*, says that today 'Death is a dreaded and unspeakable issue to be avoided by every means possible.' Geoffrey Gorer, in *The Pornography of Death*, goes so far as to claim that death has replaced sex as the major taboo of Western society.

The twentieth century effort to deny death—to keep it out of sight and out of mind—is far from the inspirational concept of the 'Beautiful Death'. Inevitably, cemeteries have reflected this change. They often restrict memorials, banning not only statuary and monuments, but even vertical headstones, so as to be able to mow the grass without impediment. I am certain that my coming from this tradition of banality, repression and silence was one reason I found the European cemeteries of the nineteenth century so extraordinary and inspiring.

Before photographing in these cemeteries, I never thought that a gravesite was a necessary stimulus to memory. By their choice, which I accepted without question, neither of my parents has a grave. They never discussed their decision with me, and I would never have thought to bring it up. If my father took my mother's ashes, he never mentioned it; and I saw no reason to take his when asked, because I never believed the absence of a physical marker, whether an urn or a gravestone, would prevent me from remembering him. And it has not. I still think of both my parents often at unexpected moments which I treasure more because they are spontaneous rather than planned. But my thoughts are entirely private; as such, I recognize they are limited.

was kept at bay. Real death is anonymity—when survivors finally forget. So the various forms of commemoration helped keep the loved ones alive—in one's consciousness.

This golden age of cemetery commemoration that I so enjoyed photographing seems now to have died. For various reasons, the twentieth century has not sustained the practice of elaborate cemetery commemorations. Instead, cemeteries grew boring. As artistic creativity was replaced by commercial mass-production, memorials became bland, repetitive, and unconvincing. Jessica Mitford, in her book, *The American Way of Death*, asks what future archaeologists will think of twentieth century culture as they pick through our cemeteries, finding '…the mass-produced granite horrors, the repetitive flat bronze markers (the legends, like greeting cards and singing telegrams, chosen from an approved list

I now understand that remembering is not the same as grieving, any more than thinking is acting. One of the lessons I learned from my experience in the cemeteries is that grief needs to be ritualized to be effective. One of the most powerful rituals of mourning is the visit to the gravesite; and I have to admit, that is something I have never done for anyone I love.

Based on what I have been observing in my own country, I believe we are evolving a new sensibility with regard to mourning. We are becoming more aware of death and, more importantly, we are beginning to develop new ways of coping with it. It may be due to AIDS, or the high incidence of cancer; it may simply be the demographics of the baby-boomer generation. Whatever the cause, death has once again intruded upon our consciousness, making its presence felt to younger segments of the population well before what we assume to be its normal time.

As a result, the forms of mourning with which we grew up no longer seem adequate for paying homage to those we have loved and lost. Victims of AIDS, often in their twenties or thirties, were often denied access to traditional avenues of mourning. In the early years of the epidemic, if not now, churches were closed to them; even their families rejected them. They and their friends were forced to develop new rituals; they did so with great imagination and feeling. The most creative memorial to AIDS victims was the AIDS quilt—a square of cloth created by friends for each of the deceased on a giant tapestry that travelled the country. Much emphasis was also placed on the memorial service; sympathetic churches and clergy were found; friends encouraged to pay tribute; families brought together. The hospice movement, long active in Britain, was adopted in order to provide dignity for the terminally ill who otherwise might be left alone. Cancer support groups have also proliferated and, like the hospices, seek to ease the pain of the disease for both patient and family. Today, families and friends are not waiting until after death to pay their respects and express their love.

Only time will tell if these changes represent anything like the 'revolution in feeling' at the end of the eighteenth century observed by Philippe Aries. Cemetery commemoration has not been the focus of recent attempts to re-define mourning rituals; and it is not yet clear how these trends will find their way into cemeteries. To determine that we will have to look at specific communities. No matter what the broad inspiration (whether it be global or national), if cemetery commemoration is to change, it will happen on the local level. When photographing in cemeteries I found that each region, not just each country, has its own visual language of mourning, like a local dialect. This is apparent in broad outline immediately upon entering the cemetery gate. Yet, in every cemetery, no matter how prevalent the local visual dialect, some tombs always stand out—someone always exceeds the norm or varies the form in an attempt to make that grave more personal, more expressive. My interest was not in documenting local differences but in photographing the individual graves of those who chose to be different. After a while, I began to call these unusual tombs the soloists among the chorus.

These so-called soloists can also be seen as change agents—the ones who dared to break the mould—in death, if not in life. They remind us that commemoration is individual and personal; that change comes from the bottom up; and, in a paraphrase of one of the precepts of community activism, they instruct us to 'think eternal; act local'. ◆

TRACES OF IMMORTALITY BIBLIOGRAPHY

Philippe Aries, *The Hour of Our Death*, Oxford University Press, New York, NY 1991

Philippe Aries, *Images of Man and Death*, Harvard University Press, Cambridge, Ma, USA 1985

Felix Barker, *Highgate Cemetery*, John Murray, London, England 1888

James Stevens Curl, *A Celebration of Death*, B.T. Batsford, London, England 1993.

Richard A. Etlin, *The Architecture of Death: The Transformation of the Cemetery in Eighteenth Century Paris*, MIT Press, Cambridge, Ma, USA 1984

Kenneth Hudson, *Churchyards and Cemetries*, The Bodley Head, London, England 1984

Elisabeth Kubler-Ross, *On Death and Dying*, MacMillan, New York, NY, USA 1969

Hugh Mellor, *London Cemeteries*, Avesbury, Amersham, England 1981

David Robinson, *Saving Graces*, W. W. Norton, London, England 1995

David Robinson, *Beautiful Death*, Penguin Studio, London, England 1996

Walking the Dog

DAVID BURKETT

Mr Smith takes his dog out for a walk every morning before work. One day he decided to walk through the cemetery—something he'd never done before. There weren't many people about at 7 a.m. but he passed one man who cheerily called out 'Morning'. Mr Smith responded equally cheerily 'No, I'm taking my dog for a walk.' That was Mr Smith's first foray into his local cemetery in all of the seventeen years he had lived in London.

The cemetery had first opened early in Queen Victoria's reign. He had passed it many times over those seventeen years but had never ventured in. He found it a fascinating place and from then on his poor old dog got led round it several times a week. It wasn't only the Victorian and Edwardian headstones, box tombs, ledgers, mausoleums and columns which he found interesting, with their wonderful inscriptions—or even lack of them after one hundred years and more—but the beautiful carvings and shapes; so much more artistic than a lot of the modern ones which he found banal and lacking in aesthetic merit.

Then there were the beautiful trees, shrubs, wildflowers and ivy, lending beauty to the stonework; and the wildlife too—squirrels, foxes, the occasional domestic cat (or so he thought) and an amazing variety of birds. He lost count of all the different birds he saw during the year. His favourite was a bold and cheeky robin which sometimes seemed to follow him and his dog around. Even Rover began to enjoy the place in spite of having to be kept on a lead. There were strict notices about dogs—and about cyclists (although sadly, most of them seemed unable to read).

Having discovered his local cemetery, Mr Smith found, as many others have done and do, that whilst it is a place for the repose of the dead, it is a place for the living too. He had always thought that a cemetery was somewhere to go when a loved one died; say, once a week at first to lay flowers, then less frequently as the years roll by. But no! He found it to be a place for the living to study all those wonderful stones and flora and fauna; a place of peace and tranquillity cut off from the mad world outside by a tall wall and iron gates; somewhere he could relax and find endless interest as the seasons change.

As time passed he became more familiar with the cemetery; yet he was always finding something new. One day, while enjoying an afternoon off, he was chatting to a gravedigger when he noticed by his left foot a red granite ledger stone with some figures and squiggles on it. (He had always thought that a ledger was something to do with accounts, but now he knew better.) He made a drawing of the squiggles on his pay packet and showed them later to his wife, who declared them to be Pitman's shorthand. Then there was the stone in memory of a choir boy, with a few bars of music; the memorial to a man killed elephant-shooting in Africa, and another to the man who built a railway in the wilds of Russia in the 1880's. These were just a few of the many treasures he discovered, some of which he researched in his local library. He came to describe this place of elegant, stately, imposing statues and stonework as a vast outdoor museum.

So, as Mr Smith discovered, you too can enjoy your local cemetery, for it is a wonderful place. It can be an outdoor museum, a wildlife park, a painting or photography opportunity, a place for school kids (and adults) to learn first-hand about flora and fauna, basic geology and social history etc., and a place to take your dog for a walk (but on a lead of course). You won't know what you're missing until you venture in. And it would be such a shame to delay your visit until after you are dead! ◆

ERIC MARLAND

NOTES ON CONTRIBUTORS

David Burkett of Kensal Green Cemetery and West London Crematorium, came to cemetery management in 1979 when he joined the General Cemetery Company as its Secretary and Registrar. He takes great interest in the varied aspects of operating an historic working cemetery, with particular emphasis on the promotion of fine-quality modern craftsman-made memorials, and the preservation of all aspects of the Victorian heritage for which the cemetery, founded in 1832, is justly famous.

Christopher Clark QC took silk in 1989 and became Chancellor of the Diocese of Winchester in 1993. With a wide variety of interests, he recently became a Lay Reader in the Church of England. He feels passionately that churches are not just architectural treasures to be clinically preserved in aspic, but are places to be used, and possibly adapted, for living and creative worship, so that the Christian message can be passed down through the generations.

Richard Kindersley has a studio in London where he and his assistants carry out lettering commissions. In 1994, he was awarded the Royal Society of Arts Award for Art and Architecture. He has carried out commissions for most of the cathedrals in the UK and has won numerous public arts competitions. He regularly writes, lectures and broadcasts on lettering and public art.

Lucinda Lambton is a writer, photographer and broadcaster and an Honorary Fellow of the Royal Institute of British Architects. She has written and presented fifty-two films for television and is the author of nine books. She is a passionate advocate for cemeteries being restored to their originally inspiring role of spiritually uplifting oases.

Tom Perkins is a Fellow of the Society of Designer-Craftsmen and the Calligraphy and Lettering Arts Society. He has exhibited widely and his work has been featured in numerous publications. His many commissions for carved lettering include work at Westminster Abbey, Magdalen College Chapel, Oxford, The Crafts Council, London and, most recently, a sign for a new opera school in Glasgow.

Alan Powers is a writer and lecturer on art, design and craft; Librarian of the Prince of Wales Institute of Architecture; Vice-Chairman of the Twentieth Century Society, and a member and Honorary Librarian of the Art Workers' Guild. Several of his current projects are concerned with specific instances of a general theme: the re-interpretation of the visual arts in Britain in the last 100 years and the re-definition of the Modernist project as a return to tradition, with special reference to its social, spiritual and ecological aspects.

David Robinson is a writer and photographer who spent two years photographing cemeteries in Paris and in Europe. He produced two books on European cemeteries, *Saving Graces* (1995) and *Beautiful Death* (1996). His photographs are in several museum collections including the Museum of Fine Arts in Boston and the Bibliothèque Nationale in Paris. He teaches photography workshops and writes on travel. His articles have been published recently in the *Los Angeles Times*, the *Chicago Tribune* and *Travelers Tales*. He lives in Mill Valley, California.

Nicholas Sloan has worked alone as a lettercutter and designer since 1975. A large tonnage of work for the poet, Ian Hamilton Finlay has balanced the staple diet of gravestones and other memorials. He has also printed sporadically under the imprint Parrett Press since 1980, producing, for example, the first two editions of the *Memorials by Artists* booklet.

Charles Smith. After an apprenticeship with a firm of monumental masons, Charles Smith became an independent lettercutter, carver and calligrapher. His work can be found on public buildings, cathedrals, churches, and in churchyards. With a love of music, natural history and walking, his main concerns are caring for the environment, and making work that looks to the future. He would welcome opportunities to do more 'green' sculpture.

ACKNOWLEDGEMENTS

We would first like to acknowledge Peter Burman and Alec Peever who both helped so much in getting *Memorials by Artists* off the ground in 1988. Also Andrew Hunter (of Gainsborough's House, Sudbury) who first approached us with the idea for the exhibition, Barclay Price who encouraged us in our vision, David Adshead, Ian Wallis and Joy Durrant of Blickling Hall, Janet Harker the exhibition designer and co-ordinator, Tom Perkins, letter-cutter, Linda Theophilus, freelance exhibition designer, Stephen Raw, the designer for the indoor exhibitions and *The Art of Remembering* book, Simon Frazer who wrote the text for the indoor exhibition panels and Oliver Riviere the photographer of all the works.

Special thanks to Rae Cole for allowing us to exhibit the memorial to her husband (designed and carved by David Holgate) and to Mr and Mrs Sims for allowing Ieuan Rees to make a likeness of the headstone he designed and carved to their daughter, Ruth. Also to all our past clients who allowed us to use photographs of the memorials they commissioned.

We are also very grateful to the following for use of photographs/slides for the indoor exhibitions: The Commonwealth War Graves Commission, Guildhall Library-Corporation of London, The National Inventory of War Memorials at the Imperial War Museum, School of World Art and Museology (University of East Anglia), Sotheby's, The V & A Picture Library, Carlisle Cemetery, The Friends of Highgate Cemetery, Kensal Green Cemetery, Worthing Cemetery. *Photographers*: Maxine Adcock, Hilary Lees, Oliver Riviere, David Robinson, Anthea Sieveking, Julius Smit, Alan Spencer and Richard Tilbrook. *Individuals*: Guy Bettley-Cooke, Martin Jennings, Lida Lopes Cardozo Kindersley, Richard Kindersley, Gillian Maddison, Norman Routledge, Nicholas Sloan, Petra Tegetmeier, Caroline Webb.

With special thanks to: David Jacobs, Julien Litten, Robert Mitchell, Idris Parry, Marilyn Smith, Michael Schmidt of Carcanet Press and Canon Keith Walker.

Steve Cowley and all the staff from the Estate Yard Owen Sayer and all the gardeners at Blickling.

There are many more people who have helped us and given us advice, including all the artists exhibiting and many of those on our register who were not able to participate. We are deeply grateful.

We both thank our families so much for their help and advice and their loving patience and *sense of humour*.

The Art of Remembering has been funded by: The E M Behrens Charitable Trust*, The David Cohen Family Charitable Trust*, The Crafts Council, Eastern Arts, The Hedley Foundation*, The Esmée Fairbairn Charitable Trust*, The J Paul Getty Jr Charitable Trust*, The Hedley Foundation*, Memorials by Artists, Dolf Mootham, The National Trust at Blickling, The Nichols Charitable Trust*.

*The Trusts marked with an aserisk have made offers of grants for *The Art of Remembering* exhibition once *Memorials by Artists* has gained charitable status.

FURTHER READING:

Alan Bartram *The English Lettering Tradition* Lund Humphries 1986

Frederick Burgess *English Churchard Memorials* Lutterworth Press 1963 (and SPCK 1979)

Peter Burman and Henry Stapleton (Ed) *The Churchyards Handbook* Church House Publishing (2nd edition) 1988

Islay Donaldson *East Lothian Gravestones* East Lothian District Library 1991

Harriet Frazer (Ed) *Memorials by Artists Booklet* Memorials by Artists (3rd edition) 1998

Andrew Graham-Dixon *A History of British Art* BBC Books 1996

Nicolette Gray *A History of Lettering* Phaidon 1986

Michael Harvey *Carving Letters in Stone and Wood* The Bodley Head 1987

David Kindersley & Lida Lopes Cardozo *Letters Slate Cut* Cardozo Kindersley Editions 1990

Hilary Lees *Hallowed Ground—Churchyards of Gloucestershire & The Cotswolds* Thornhill Press 1993

Hilary Lees *Hallowed Ground—The Churchyards of Wiltshire* Picton 1993

Hilary Lees *Cornwall's Churchyard Heritage* Twelveheads Press 1996

Kenneth Lindley *Graves and Epitaths* Hutchinson 1965

Nigel Llewellyn *The Art of Death* Reaktion Books in association with The V & A Museum 1991

Richard Tilbrook and C V Roberts *Norfolk's Churches Great and Small* Jarrold Publishing 1997

Betty Willsher & Doreen Hunter *Stones-a Guide to Some Remarkable 18th Century Gravestones* Canongate 1978

Betty Willsher *Understanding Scottish Graveyards* Chambers 1985

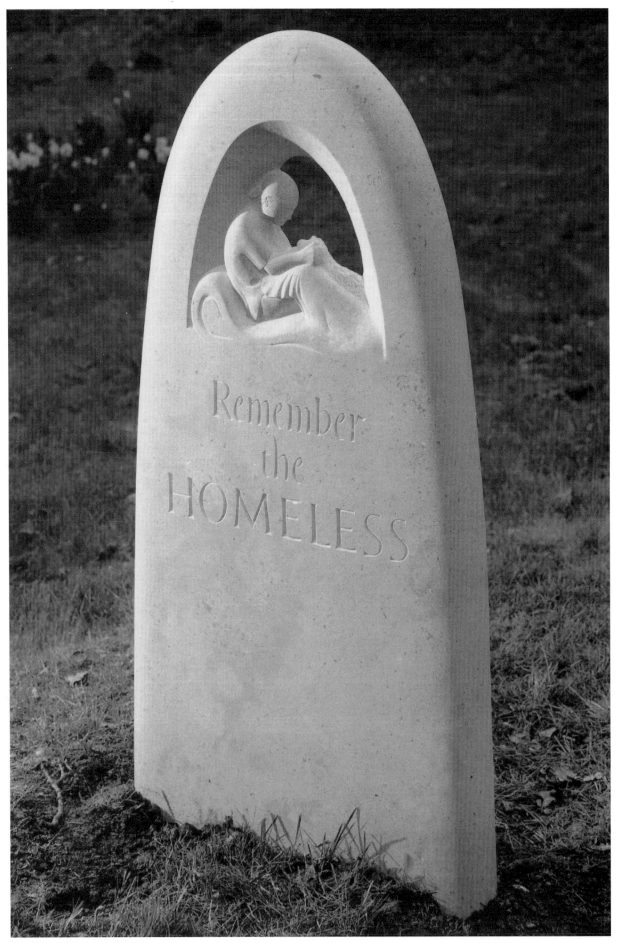

GEOFFREY ALDRED